Learn to Draw

HORSES

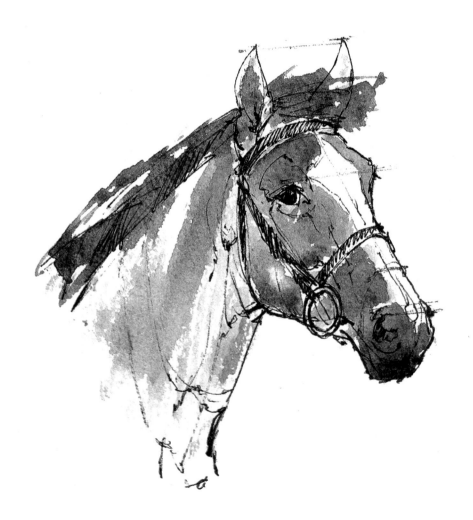

David Brown

HarperCollins*Publishers*

First published in 1995
by HarperCollins Publishers
London

© HarperCollins Publishers 1995

Editor: Diana Craig
Art Director: Pedro Prá-Lopez, Kingfisher Design Services
DTP/Typesetting: Frances Prá-Lopez, Kingfisher Design Services
Contributing artist: Louise Mizen

A catalogue record for this book is available from the British Library

ISBN 0 00 412747 1

Printed and bound in Hong Kong

CONTENTS

Introduction

Drawing gives me a great deal of pleasure which I would like to share with you. Just by the simple act of choosing this book, you have shown that you are interested in the art of drawing and, in particular, drawing horses.

A passion for horses is understandable: they are magnificent animals. To stand close to a workhorse and experience its immense, muscular presence, its great strength and power, and yet at the same time be struck by its gentleness, can be an unforgettable moment.

Ideal subjects

Because of their generally placid nature, horses make excellent subject matter. There are many occasions when they remain relatively still, and these provide the perfect opportunity for drawing: you can, for example, study them at leisure when they are grazing in a field or when they are being groomed. Since horses have no long body hair, it is also easy to see their muscular structure, and this makes them fascinating creatures to draw from whichever viewpoint you choose.

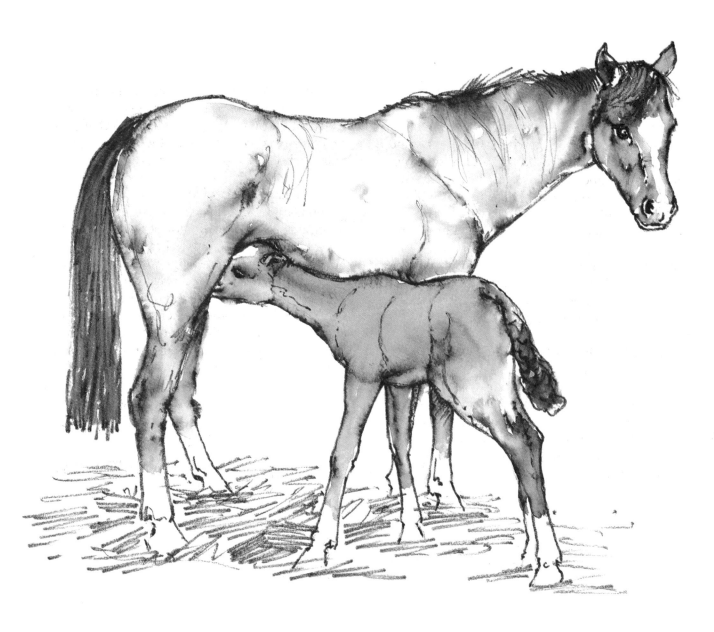

Not *all* horses are placid, of course, and you should always exercise caution when approaching one. Keep a reasonable distance between you, especially when standing behind the animal. A horse could take fright for some reason, and unexpectedly bolt or kick out – or have its attention suddenly distracted, with similar results. I remember my wife being unseated by a horse when pony-trekking in mid-Wales. Apparently he had developed a liking for a certain plant that grew on some of the hills and, whenever he saw a clump, would suddenly shoot off in that direction regardless of where the rider wanted him to go.

The skills of draughtsmanship

In this book, I will attempt to explain and teach you the 'mechanics' of drawing horses – for example, how to work out proportions, understand the rules of perspective, and cope with light and shade. In other words, I will try to help you to handle the basics of good draughtsmanship correctly.

As with all skills, there is no substitute for practice, so draw as often as you can. Get into the habit of carrying a pocket-sized sketchbook on you so that you can instantly capture a good subject should the opportunity arise.

A relaxed approach

When learning to draw, one important thing to remember is not to aim for perfection every time. If you say to yourself, 'I am going to try to do a drawing good enough to frame,' you will start to concentrate more on *how* you are drawing and not on *what* you are drawing, and this will make you tighten up and become apprehensive about the result. So just relax, regard each drawing as practice and your work will improve of its own accord.

Tools and Equipment

The range of art materials is very extensive, and therefore deciding what to buy can be daunting for the beginner, faced with such a wide choice. The first thing to remember is always buy the best you can afford. Quality materials won't make you a better artist, but they will remove the frustration of trying to cope with inferior products, such as brushes whose bristles split into separate points, or gritty pencils. To begin with, buy whatever you feel most confident in using, and then add to your collection when your enthusiasm, experience and finances allow.

Pencils

The most basic drawing tool, but also one that has an extensive range, is the inexpensive pencil. The quality of line it produces can range from very thin and light to extremely thick and dark. In the middle of the range is the HB pencil; on either side of this the Bs become increasingly soft, and the Hs increasingly hard. The higher the figure, the harder or softer the pencil: for example, 2H is hard, 9H extremely hard, while 2B is soft, and 9B extremely soft.

When doing detailed work, keep your pencil sharpened to a fine point. Because soft pencils wear down quickly when in use, you should always keep them sharp so that the point of the lead is well clear of the wood. This will prevent the wood of the pencil coming into contact with the surface of your drawing and damaging it.

In addition to the normal, pointed pencil, you can also buy chisel-ended types. As the name implies, the lead has a broad, flat, chisel shape that makes a very thick line.

There is also the vast range of coloured pencils. Interesting effects can be produced by blending one colour into another to create a third colour, or by applying different-coloured lines or dots side by side and letting the eyes do the 'mixing'.

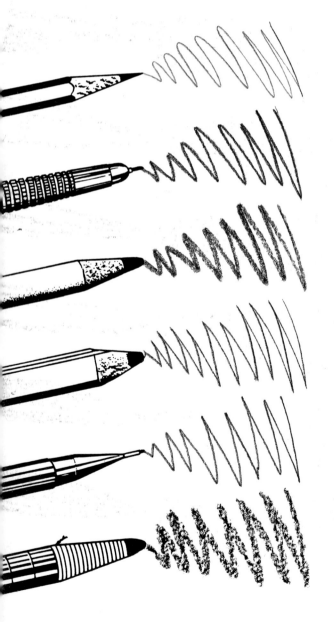

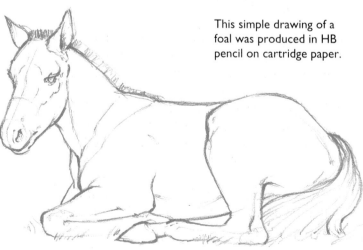

This simple drawing of a foal was produced in HB pencil on cartridge paper.

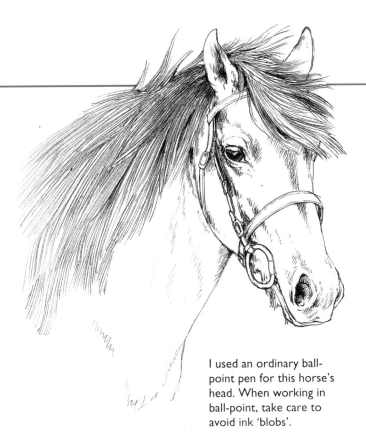

I used an ordinary ball-point pen for this horse's head. When working in ball-point, take care to avoid ink 'blobs'.

Pens

It is impossible to cover the whole range of pens as new ones are constantly being added, but here is a selection of the most commonly used.

Dip pens are a traditional drawing tool, and consist of a holder into which a nib is inserted, and then dipped into the ink. The nibs vary in thickness, the mapping pen giving probably the finest line. Try to buy nibs with the longest distance from the point to the 'shoulder', as these give the greatest flexibility of line.

Fountain pens are good for carrying around when sketching. Some fountain pens have interchangeable heads.

Ballpoint pens are another very useful tool for sketching, but make sure you buy a smooth-running one that doesn't produce a blotchy line.

Technical pens are ideal if you require a line to be of the same thickness throughout. They come in various thicknesses: the finer the line, the lower the number.

Felt-tip pens are available in many colours and vary in thickness from fine to very broad.

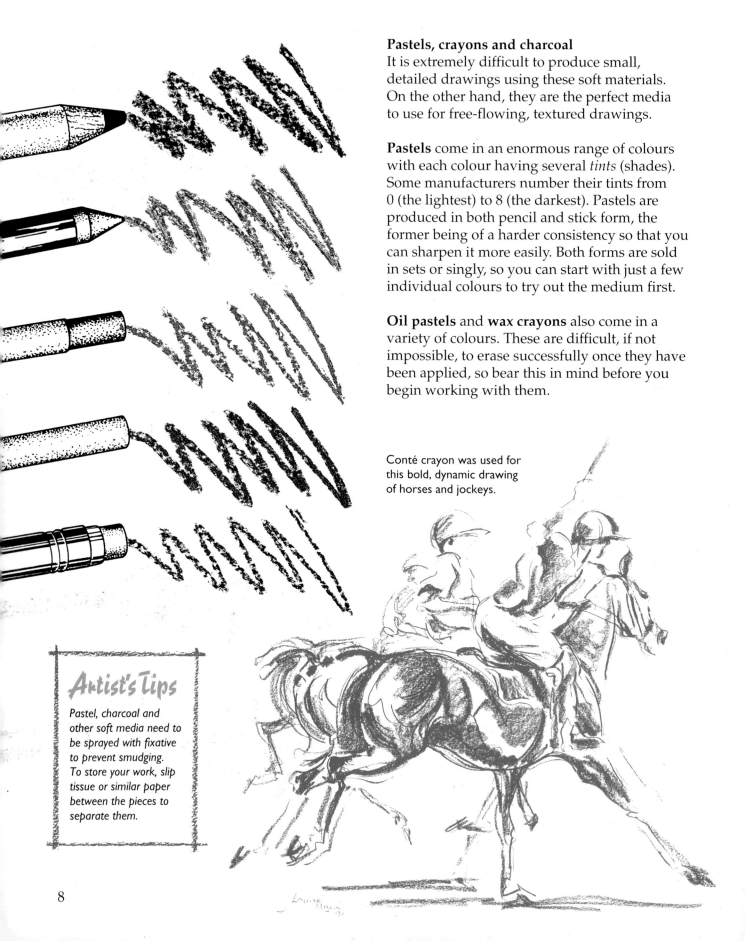

Pastels, crayons and charcoal

It is extremely difficult to produce small, detailed drawings using these soft materials. On the other hand, they are the perfect media to use for free-flowing, textured drawings.

Pastels come in an enormous range of colours with each colour having several *tints* (shades). Some manufacturers number their tints from 0 (the lightest) to 8 (the darkest). Pastels are produced in both pencil and stick form, the former being of a harder consistency so that you can sharpen it more easily. Both forms are sold in sets or singly, so you can start with just a few individual colours to try out the medium first.

Oil pastels and **wax crayons** also come in a variety of colours. These are difficult, if not impossible, to erase successfully once they have been applied, so bear this in mind before you begin working with them.

Conté crayon was used for this bold, dynamic drawing of horses and jockeys.

Artist's Tips

Pastel, charcoal and other soft media need to be sprayed with fixative to prevent smudging. To store your work, slip tissue or similar paper between the pieces to separate them.

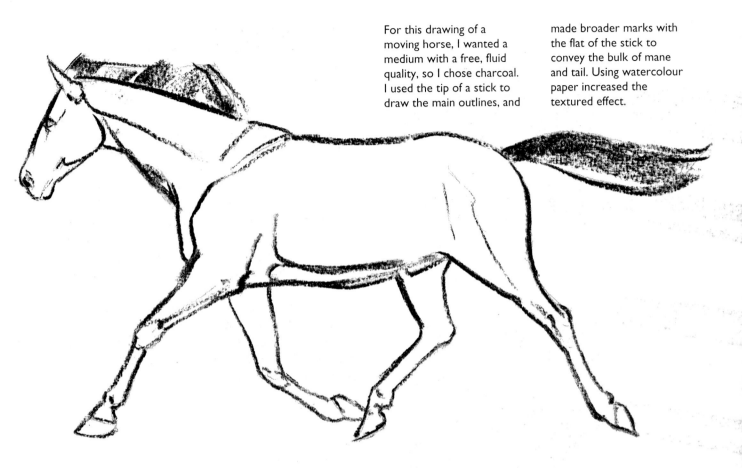

For this drawing of a moving horse, I wanted a medium with a free, fluid quality, so I chose charcoal. I used the tip of a stick to draw the main outlines, and made broader marks with the flat of the stick to convey the bulk of mane and tail. Using watercolour paper increased the textured effect.

Conté crayon is a similar medium to pastel, but has a slightly greasy texture that makes it harder and less crumbly.

Charcoal is available in both stick and pencil form. Pencils are cleaner to handle, but sticks are perfect for working on a large scale. Pieces can be broken off and the side of the stick used to produce broad strokes. This method of application can also be used with pastel and conté crayon. If you want to make finer lines, rub the tip of the charcoal on sandpaper to produce a point. Charcoal smudges very easily so avoid resting your hands on the drawing until it is properly fixed.

To pick out highlights and lighten areas in a pastel or charcoal drawing, gently dab the surface with a putty rubber. You can also blend colours by gently rubbing one into another with your fingers.

Brushes and wet media

The range of brushes is vast, in size, shape and quality. Always buy a good-quality brush, one with some spring in it which reverts back to its original shape after use. Brushes may be round, pointed, chisel- or fan-shaped. The finer the point, the thinner the line a brush will produce. Broader, flatter brushes are best for 'filling in' or laying washes.

The best-quality brushes are made of sable hair. They are the most expensive, but last longer. Cheaper, but still good-quality brushes are those made of squirrel or ox hair, or synthetic fibres.

Inks may be applied with a pen as a line drawing, used with a brush to produce a wash, or the two methods may be combined to create a line and wash drawing. To retain a clean, sharp line under a wash, use a waterproof ink.

3

5

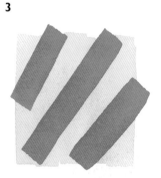

4

6

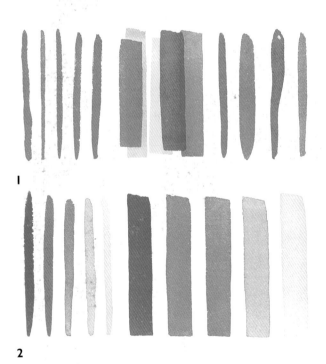

1

2

1 These brush marks were made with *(from left to right)* a small, pointed brush; a flat brush; a large, pointed brush.

2 Watercolour tone can be progressively reduced by adding more water, as shown by these strokes using different dilutions.

3 For an even layer of strong watercolour, add darker washes to a light wash while still wet.

4 To prevent colours 'bleeding' together, let the first layer dry before adding the next.

5 For a soft, blurry effect, paint watercolour on to paper that has been slightly dampened.

6 Ink or concentrated watercolour on damp paper will spread into swirls and blotches.

When your basic ink drawing is dry, a colour wash can be added over the top without dissolving the drawing underneath. Inks are brilliant in colour and can be easily mixed.

Certain inks, particularly waterproof ones, can quickly damage a brush if it is not thoroughly washed immediately after use, so keep a medium-quality brush solely for ink work.

Watercolours can be bought in tubes, small blocks called *pans*, or concentrated liquid form. They can be diluted with water to create subtle, transparent tones, or used straight from the container to produce strong, vivid colours.

Gouache is a water-based paint. It can be diluted, like watercolour, to create transparent areas, or used thickly to produce an opaque colour that is dense enough to obliterate any pencil drawing beneath it.

Acrylic paints are thick and resemble oil paint, but can be thinned by diluting with water.

Mixing colours

When using paints or inks, you will also need a water jar, and a 'palette' for mixing colours, such as an old plate, or old bun tin with separate cups for holding individual colours. Test your new colour by dabbing it on a scrap of paper or the edge of your drawing. Change the water in your jar often so that it does not tint your colours.

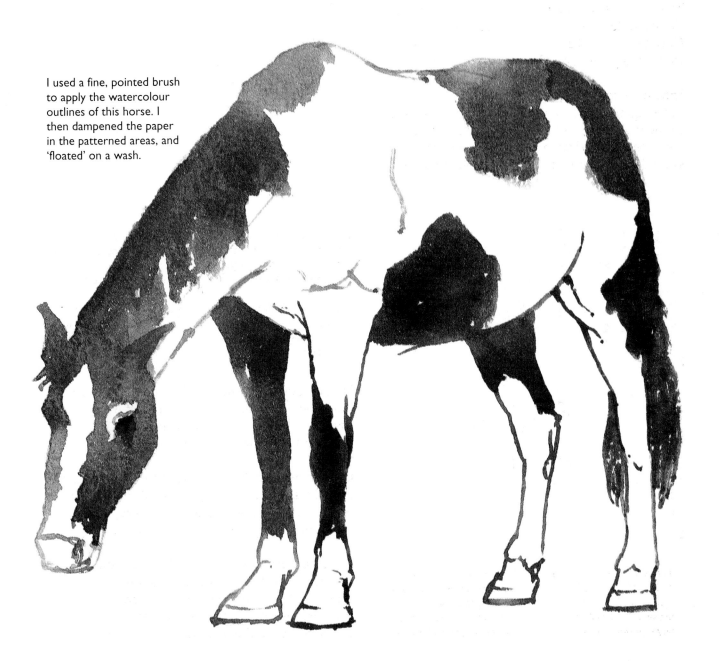

I used a fine, pointed brush to apply the watercolour outlines of this horse. I then dampened the paper in the patterned areas, and 'floated' on a wash.

Newsprint is very inexpensive, which makes it good for practising and rough sketching.

Tracing paper is semi-transparent, so that you can lay it over other images and trace them.

Stationery paper, usually available in one size, has a hard, smooth surface that works well with pen.

Cartridge paper usually has a slightly textured surface, and is one of the most versatile surfaces.

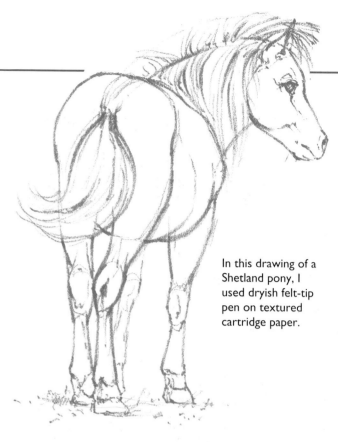

In this drawing of a Shetland pony, I used dryish felt-tip pen on textured cartridge paper.

Surfaces to draw on

There are a variety of smooth, rough, thin, thick and coloured papers and boards to choose from. When combined with your chosen medium, each will produce a different effect. Although there are no laws in art regarding the use of materials, there are instances when one medium will not work well on a particular surface but combines very well with another, so experiment with as many combinations as possible. When using a wet medium, however, it's best to stick to board or heavy paper that won't buckle.

The quality of different papers depends on how they are made: by hand, mould, or machine.

Handmade paper is made in individual sheets, so that each one is different from the next. This process is labour-intensive and time-consuming – which makes the paper very expensive – but it is a top-quality product.

Mould paper is formed into individual sheets by machine. Paper made in this way has two different surfaces: a right side and wrong side.

Machine-made paper is produced in a large roll of uniform quality, which is then cut into sheets.

Ingres paper, in various colours and with a lightly ridged surface, is ideal for pastel and charcoal.

Watercolour paper is thick and absorbent, and has a rough surface. It is good for wet media.

Bristol board is stiff and has a smooth finish that makes it a good surface for pen drawings.

Layout paper is a semi-opaque, lightweight paper that is most suitable for pen or pencil drawings.

The sheets may be sold individually or bound into a pad or book form. Machine-made papers are available in varying degrees of quality.

The surface of a paper is determined by the finishing process. *Hot-pressed* paper is smooth, *not* (i.e. not hot-pressed) paper is slightly rough, and *rough* paper has a textured surface.

This pale horse and rider was also done in dry felt-tip pen, but on CS2 'not' paper, instead of cartridge.

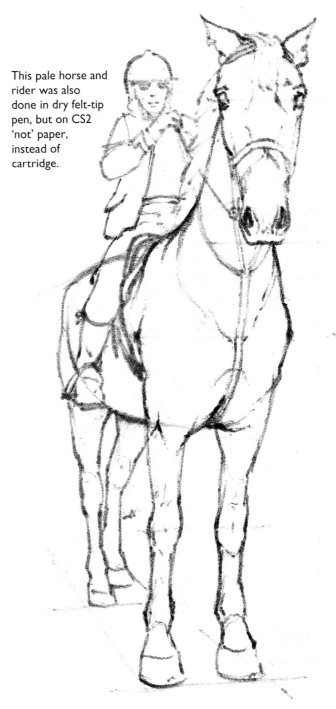

Choosing the Right Medium

Mention the word 'drawing' and the majority of people will immediately think of a pencil drawing, for the humble pencil is probably the most popular of all drawing tools. There are three reasons for this. First is the pencil's convenience – it is light, small, and therefore easy to carry about. Second, it is relatively clean to use compared with charcoal, pastel, or pen and ink. And finally, it is cheap and easily obtainable in stationery and art shops.

In spite of these obvious advantages, I would urge you to experiment by trying out as many different media as possible: only by doing this will you discover the distinctive quality of each. There will come a time when you will need to know what medium to use to help you to produce a drawing with a specific effect. Knowing the various media, and the differences between them, will help you to choose the one most likely to produce the effect you want.

As well as the tool you use, you will need to think about the surface you are going to work on, for this, too, will affect the final 'look' of your work. Experiment with different media on different surfaces, to see how various combinations work together.

In the pictures on these two pages, I have produced six drawings of the same horse's head to illustrate how much its appearance changes with each change of medium and surface.

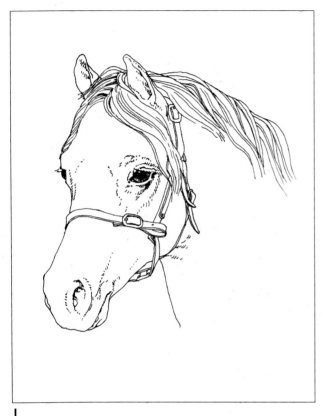

1

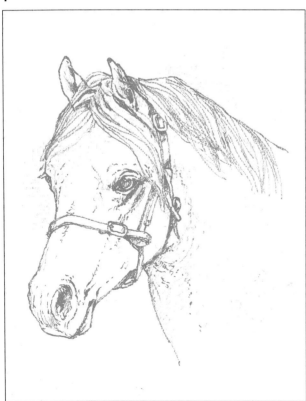

2

I Technical pen on smooth paper
2 Felt-tip pen on rough paper

3 Watercolour on rough watercolour paper
4 Pastel pencil on coloured Ingres paper
5 HB pencil on 'not' paper
6 Dip pen and Indian ink on smooth cartridge

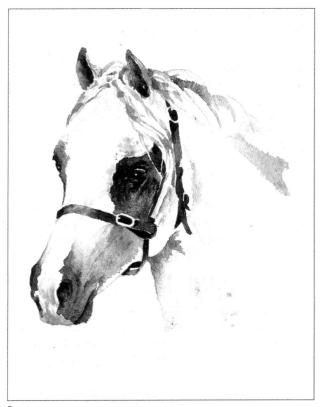

3

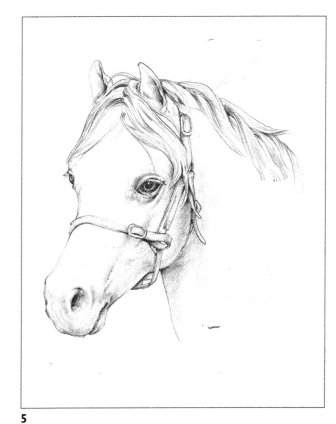

5

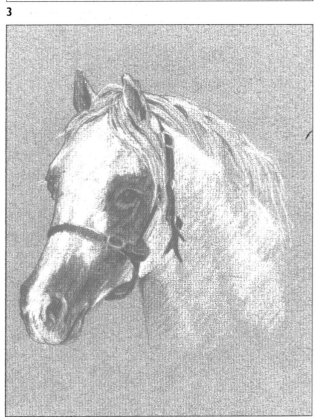

4

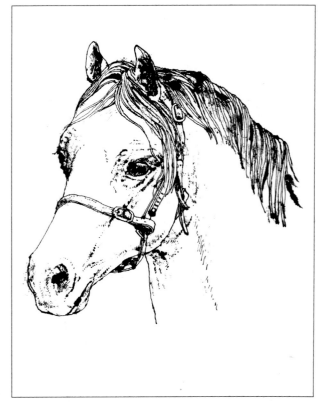

6

Proportion and Measuring

An essential part of producing a good drawing lies in getting the basics right. For many people, proportion presents one of the biggest problems, yet it is vital to achieve the correct proportions if you want your work to look convincing. Whatever your chosen subject – be it animal, human, plant or other object – if the basic structure is wrong, you will not be able to disguise the fact with shading or colour.

The pencil method
So how can you achieve this accuracy? A simple but effective method is illustrated below. Choose a portion of your subject – in this case the head of the horse – and use this as your *measuring unit*. Hold your pencil at arm's length and line up the top of it with the top of the

horse's head. Now place your thumb on the pencil to line it up with the bottom of the head. You now have a measuring unit with which to work out how many head lengths make up the length of the body; by holding the pencil horizontally, you can also tell how many make up the width.

When measuring like this, remember always to keep your arm straight, your pencil vertical, and your thumb on the same spot on the pencil.

Judging by eye
You can test yourself to find out how good, or bad, you are at judging proportions without measuring them. Choose your subject: if you don't have a live horse to draw, you could use

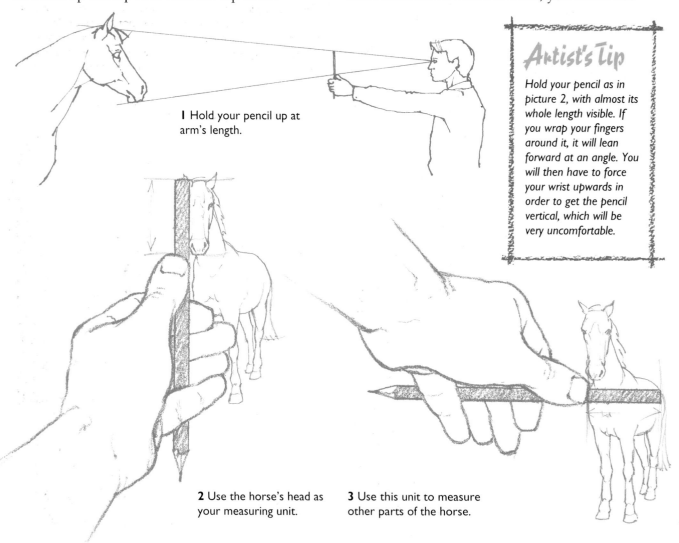

1 Hold your pencil up at arm's length.

2 Use the horse's head as your measuring unit.

3 Use this unit to measure other parts of the horse.

a photograph (a photograph may be better in this case because the subject won't move while you are doing your test!). It should be a good picture, though, and the larger, the better.

Now do a simple drawing of the horse. Don't bother with any details for this exercise – in fact, you need only put a series of marks on the paper to indicate the size of the head, how large you think the body should be, and how long the legs and other parts of the horse are in comparison to the head.

Checking your drawing

To find out how accurate you are at judging proportions by eye, compare your drawing with the photograph. First check the proportions of the horse in the photograph by the 'pencil method' already described – you don't, of course, have to do this at arm's length – and make a note of the results.

Now check your drawing in the same way. How well do the proportions in your drawing match those in the photograph?

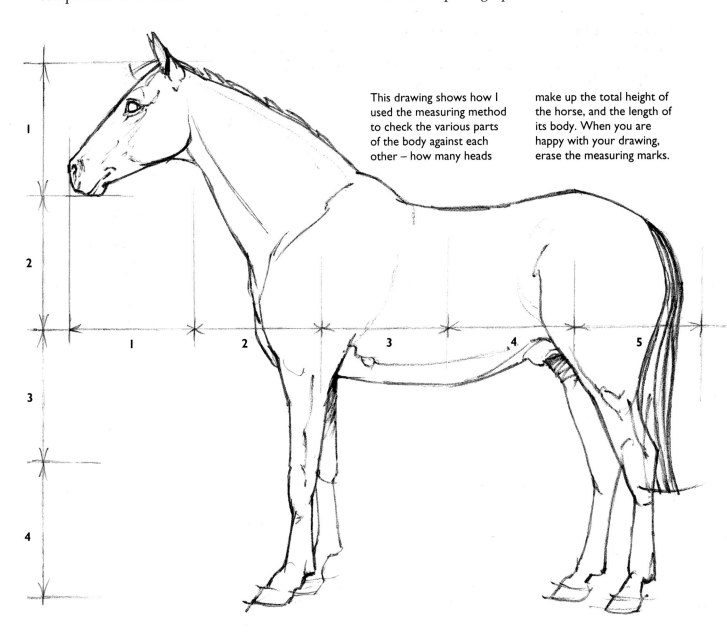

This drawing shows how I used the measuring method to check the various parts of the body against each other – how many heads make up the total height of the horse, and the length of its body. When you are happy with your drawing, erase the measuring marks.

Practice makes perfect

You should always use the pencil method of measuring when doing your basic drawing. With practice your eye and brain will become experienced enough to dispense with the technique, only using it to check your drawing if it looks wrong; until then, persevere with it. Remember, you must get the proportions and angles right when drawing your basic lines as these will be the foundations on which you will build up your drawing.

1 To draw this head, I first roughly drew the outline shape. Then I drew a line from the top of the head to the point at which the head connects to the neck (A). This was to be my unit of measurement.

3 When I had compared and corrected all the proportions and marked in the position of key details, I was able to erase my construction lines, and work up the finished drawing.

2 I noticed that the position of the eye lined up to a point half-way down line A. The distance from the back of the eye to the end of the nose, line 1(A), was the same as the length of line A, and half-way down this line gave me the position of the strap, at ½(A). I was able to compare measurements around the chin, mouth and nostril, using line B as my guide. By holding the pencil vertically, I worked out the angles in this area.

To increase your awareness of proportion, keep comparing the various sections visually as you work. For example, how does the length of the upper front leg compare to that of the back leg? How do these compare to the length of the head? How do the widths compare?

Close-up

A tethered horse gives you the opportunity to make a detailed drawing. First make a simple sketch of the shape of the head. Then take a distance between two points as a measure: for example, from the top of the head to the point where the head meets the neck – line A in the drawing on the far left. Use this as a measure to help you build up the rest of the head.

Checking the angles

In addition to checking that each part of your drawing is the correct size in relation to the others, you must also check that the angles are correct. This can be done by holding your pencil vertically in front of you so that it runs down the length of the horse. Move your eyes down the pencil, taking note of the position and angle of the various body parts in relation to the vertical line.

Using a plumbline

I remember being encouraged at art school to use a plumbline for checking angles. Making your own plumbline is a simple task: merely tie a small weight on the end of a piece of string or cotton. Then all you have to do is hold the end of the string, letting the weight hang free to give you a true vertical line. This method is more accurate than using a pencil, but it does have one disadvantage: you will need both hands to prevent the weight swinging from side to side as you move the plumbline from one part of the body to another.

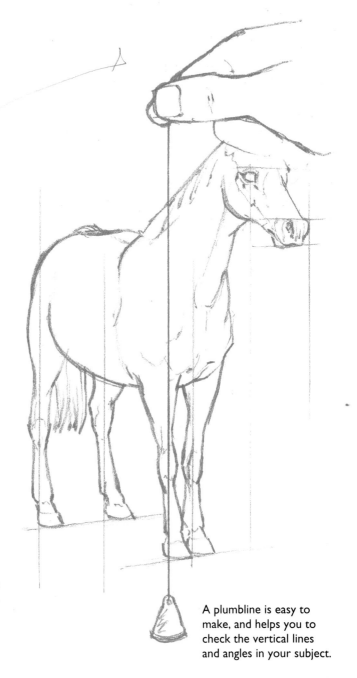

A plumbline is easy to make, and helps you to check the vertical lines and angles in your subject.

Artist's Tip

Draw your 'construction lines' lightly so that they can be erased when your outline drawing is complete, or covered with shading.

Structure and Form

In order to understand the surface shape of the horse, it is helpful to know something of its skeletal and muscular structure.

Bones and muscles

It isn't necessary to make a serious study of the horse's anatomy unless, of course, you intend to specialize professionally. But it is very helpful to carry out a limited study, making notes on how the structure of the bones – particularly those close to the surface – affects the surface shape. A general knowledge of the muscles which directly affect the surface would also be useful.

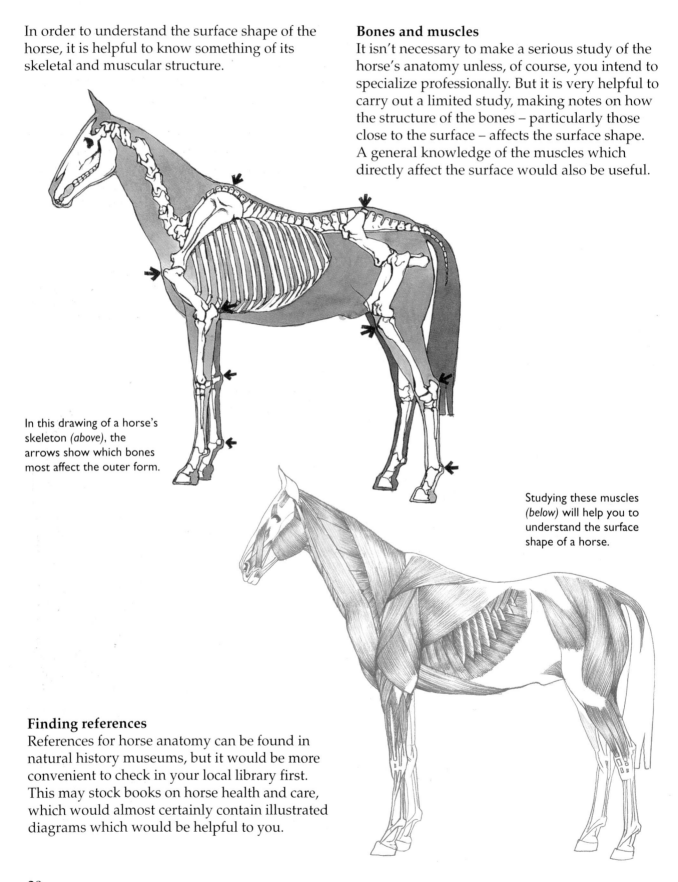

In this drawing of a horse's skeleton *(above)*, the arrows show which bones most affect the outer form.

Studying these muscles *(below)* will help you to understand the surface shape of a horse.

Finding references

References for horse anatomy can be found in natural history museums, but it would be more convenient to check in your local library first. This may stock books on horse health and care, which would almost certainly contain illustrated diagrams which would be helpful to you.

Perspective

If you want your drawings of horses to look convincing, you'll also need to know something of the rules governing perspective. Perspective is an optical illusion which allows artists to represent three-dimensional objects on a flat, two-dimensional surface.

There are three forms of perspective: *linear*, *tonal* or *aerial*, and *foreshortening*. All three can be used to convey depth and distance. Knowing how they work is indispensable when constructing your three-dimensional drawing.

Linear perspective rules that objects decrease in size the further they are from the person viewing them. So a horse in the foreground of a picture will appear larger than a horse in the middle ground or distance – although, in reality, the two may be the same size.

Because of perspective, the hind quarters of the smaller horse *(below left)* hide its shoulders, and make its head appear smaller. In the larger horse *(below right)*, lines have been used to work out the angles.

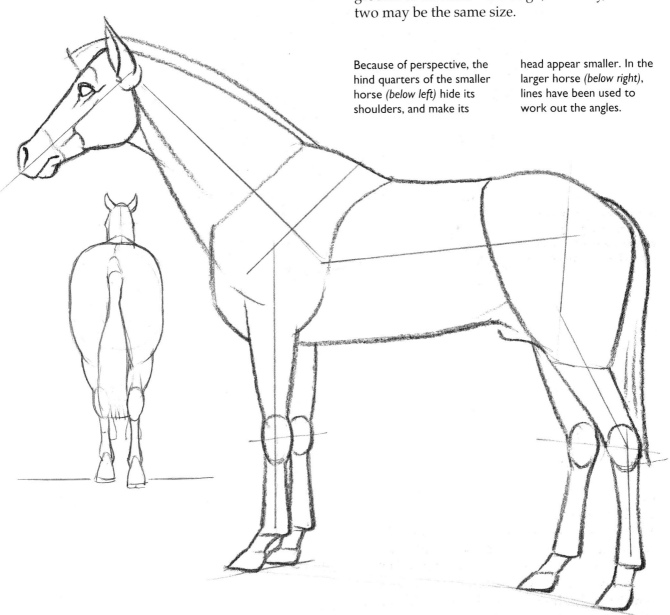

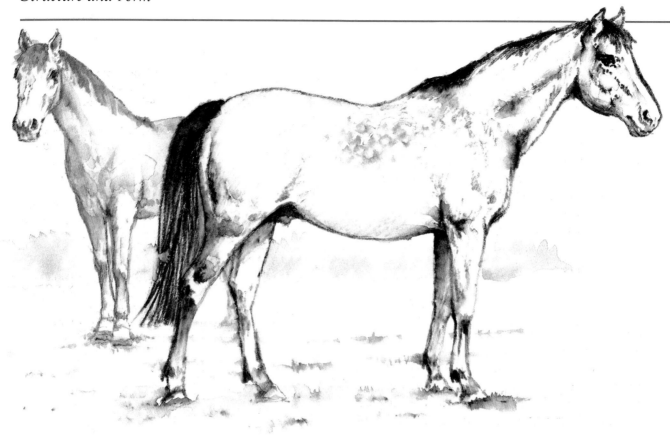

This drawing (*above*) illustrates the effects of both linear and tonal perspective. The horse on the left is clearly to the rear of the scene because it appears smaller. It is also paler in tone, conveying a sense of distance.

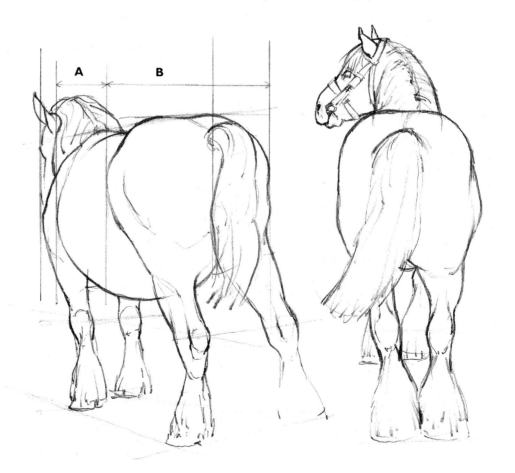

Drawing vertical lines down the various sections accentuates the foreshortening of this workhorse (*right*). You can clearly see how small an area is taken up by the body (A), compared to the hind quarters (B). The foreshortening of the horse on the far right is so severe that the body has virtually disappeared.

Tonal perspective is an illusory effect that makes distant objects appear lighter in colour and outline than those nearer the observer. It is caused by the atmosphere which subdues colours and reduces the differences between light and shade. This will, of course, be hardly noticeable when viewing a horse, as one end would not be far enough away from the other to make any difference. You can use 'artists' licence', however, and exaggerate this illusion to help to convey depth and achieve a three-dimensional effect.

Foreshortening works in a similar way to linear perspective, except that it distorts the proportions in a single object, making the part nearest the viewer appear larger, and the part furthest away appear smaller. This makes it all the more important to use the measuring method described on pages 16-17 when working out the position and proportions of the various features and sections of the horse. You will be surprised at how small an area some of the body parts occupy when foreshortened.

Horses' legs

One area that is sure to cause the beginner problems is the lower part of the leg. However, with careful observation and repeated practice at drawing this part, you will soon be able to obtain creditable results.

The drawings on this page will, I hope, help you to understand the structure of the lower front leg. Drawing 1 is a front view of a horse's right leg. Notice the slight angle through the ankle and knee joints (on the left leg, of course, they would slope in the other direction. Hold the drawing in front of a mirror to see this).

Compare drawings 1 and 3 (a side view of a leg) to the two simplified drawings 2 and 4. You will notice that in drawing 2 the leg is virtually the same width across the B and C lines, narrowing slightly between the two, whereas when looked at from the side, in drawing 4, the leg becomes wider as it descends to the ankle.

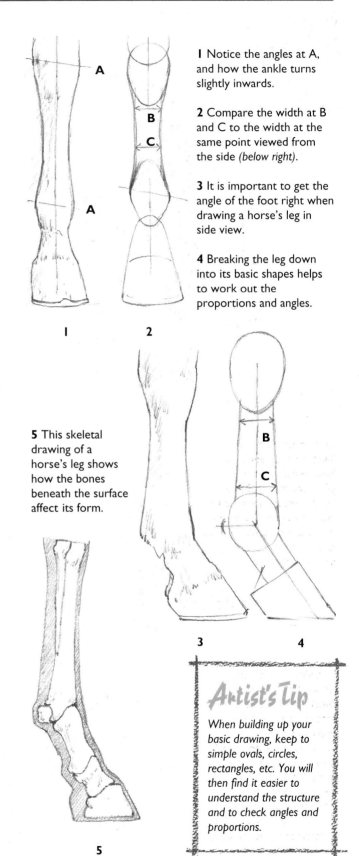

1 Notice the angles at A, and how the ankle turns slightly inwards.

2 Compare the width at B and C to the width at the same point viewed from the side *(below right)*.

3 It is important to get the angle of the foot right when drawing a horse's leg in side view.

4 Breaking the leg down into its basic shapes helps to work out the proportions and angles.

5 This skeletal drawing of a horse's leg shows how the bones beneath the surface affect its form.

Artist's Tip

When building up your basic drawing, keep to simple ovals, circles, rectangles, etc. You will then find it easier to understand the structure and to check angles and proportions.

Looking at Features

Horses' heads are full of intricate shapes and are fascinating to draw. To understand how these shapes work, do as many drawings as you can, perhaps keeping them all in one sketchbook for convenience, which you can then refer back to when you are unsure of some detail. In this way, you will build up knowledge which in time will enable you to produce drawings without having to check references.

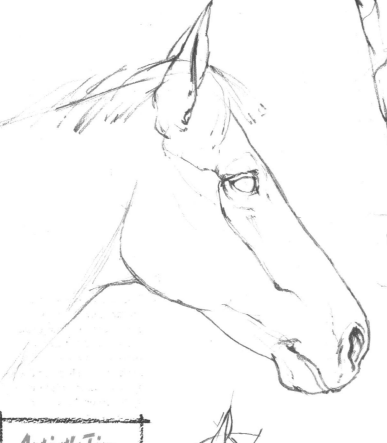

Artist's Tip

Imagine that you could trace your finger around a horse's head and 'feel' the shapes: where they are broad and flat, where they are rounded, or hollow. Now translate these contours into actual 'construction' lines on your drawing.

Here (*above* and *left*) you can see the advantage of drawing from different viewpoints. It would be very difficult to visualize what the front view of the head would look like merely by studying the head in profile.

Features

A horse's head is essentially an elongated cube, constructed from various different features and forms. When you do your drawing, observe how the different features relate to each other – how one form flows into or moulds itself around the next – and how the forms all fit together into the overall structure of the head.

Study the eye carefully; what shape are the eyelids and how do they relate to the eye? How do the eyes fit into the head? How do they relate to the position of the ears and what area of the head do they occupy?

Now look at the shape of the nostrils, and the proportion of the area they take up. How far does the mouth extend up the side of the head?

Changing viewpoints
As you shift your viewpoint, so the features and forms in a horse's head shift in shape and angle, too. To get a feeling for these changes, study the head from a variety of positions – for example, do a side view, then a view from the front, then a three-quarter view. Notice how the shape of the nostrils changes, also the eyes. Look at the changing shape of the ears. Make detailed drawings of all of these different parts from various viewpoints.

This profile *(above)* is a similar view to the one below, but I did not draw it from so extreme an angle. Compare the position and shape of the eye and nostril with those in the other drawings on these two pages.

This three-quarter view *(left)* has a more three-dimensional feeling because it is seen from behind, so that the underneath as well as the side of the head is visible.

Ears

Although they appear simple at first glance, ears are really quite complex when studied in detail. Many people experience difficulty in placing the ears in the right position on the head.

To help you to overcome this difficulty, add a little of the surrounding area when doing your drawing, making a graphic note on how the ears relate to, say, the position and angles of the eyes. This can be done by adding lines as shown in the drawing below. You can clearly see how, in this particular pose, the lines fanning out from the ear relate to the lines of the eye and neck. Look carefully, too, at how the ears 'grow' out of the head.

The angle and shape of the ears does change, of course, depending on what the horse is doing. A horse will twist its ears around and back if it is interested in some sound from behind – and if sounds come from several directions at once, the horse may simultaneously have one ear angled forward and the other back!

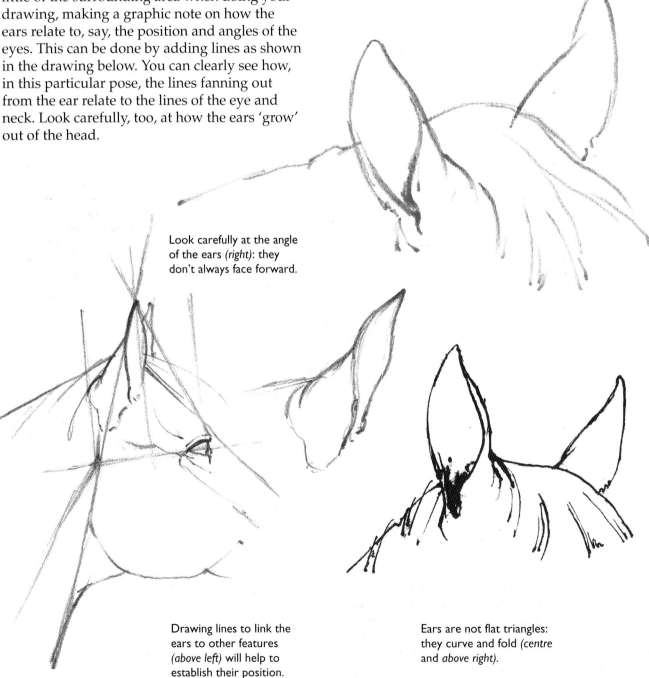

Look carefully at the angle of the ears *(right)*: they don't always face forward.

Drawing lines to link the ears to other features *(above left)* will help to establish their position.

Ears are not flat triangles: they curve and fold *(centre* and *above right)*.

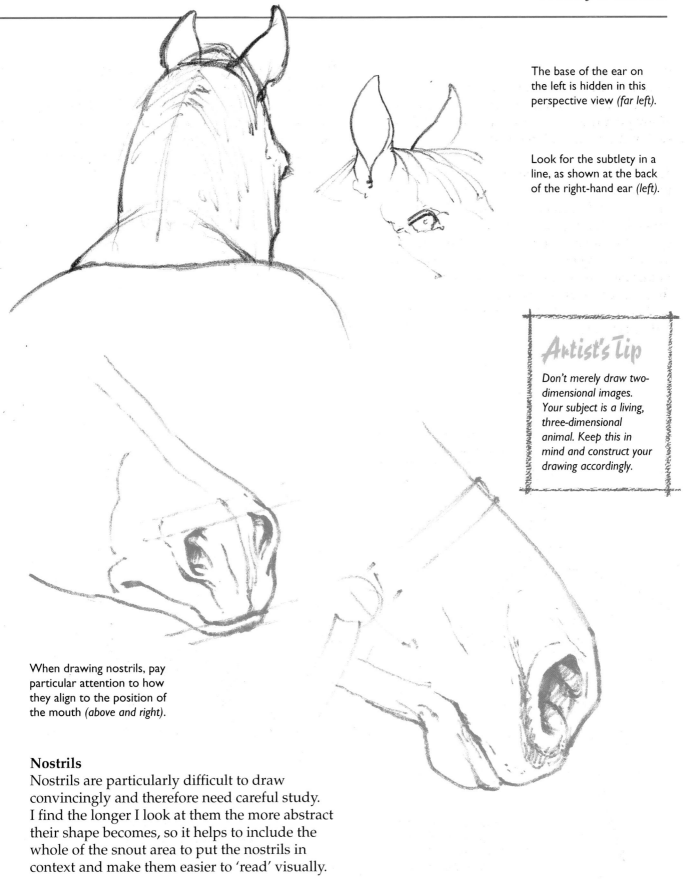

The base of the ear on the left is hidden in this perspective view *(far left)*.

Look for the subtlety in a line, as shown at the back of the right-hand ear *(left)*.

Artist's Tip

Don't merely draw two-dimensional images. Your subject is a living, three-dimensional animal. Keep this in mind and construct your drawing accordingly.

When drawing nostrils, pay particular attention to how they align to the position of the mouth *(above and right)*.

Nostrils

Nostrils are particularly difficult to draw convincingly and therefore need careful study. I find the longer I look at them the more abstract their shape becomes, so it helps to include the whole of the snout area to put the nostrils in context and make them easier to 'read' visually.

Different Breeds

There are many different breeds of horse, each with its own distinctive characteristics of shape, size and proportion. You could study the differences between the various breeds by finding references for as many of them as possible, and making careful drawings of each.

As you build up your study collection, take note of what it is that makes one breed different from another. For instance, in what details does a Shetland pony differ from a hunter? Look at age differences, too: how does a foal differ from a full-grown mare?

Workhorses and thoroughbred horses

The most obvious difference is that between a workhorse and a thoroughbred. Leg length is probably the most striking distinction here. Although both types have fairly bulky bodies, the legs of thoroughbreds are long and slender in proportion to their bodies, while those of workhorses are much shorter. Workhorses have a much stockier build altogether.

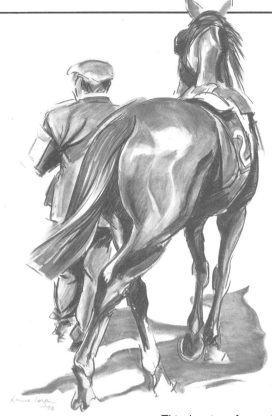

This drawing of a racehorse (*above*), done in conté crayon, shows its characteristic length of leg. Notice the fluid, backward sweep of its hind legs.

In proportion to its body, the legs and neck of this Ardennais (*left*) are much shorter and thicker than those of the racehorse (*above*). I needed a bold medium to convey the muscular strength of this workhorse, and used charcoal pencil.

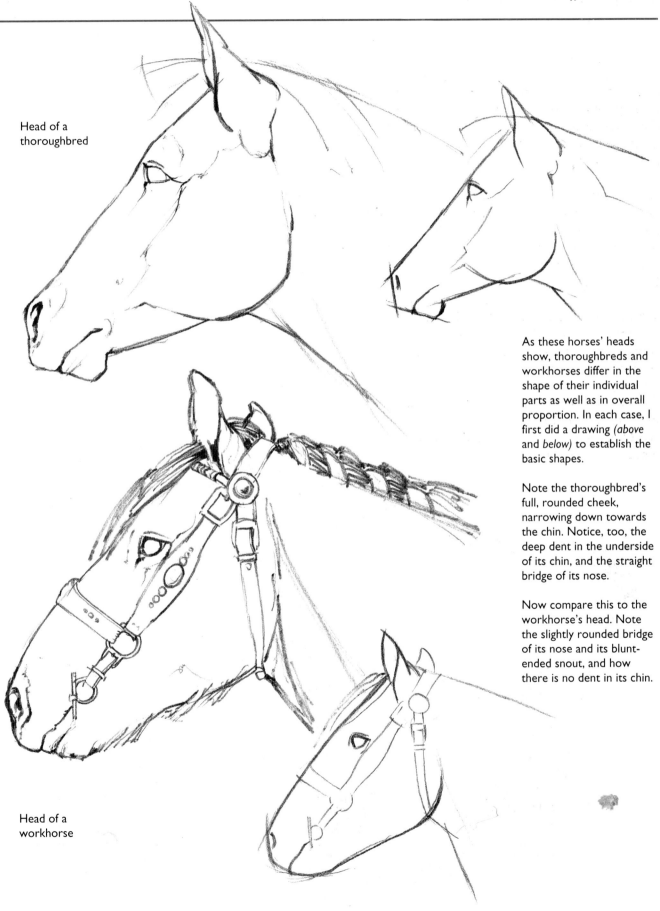

Head of a
thoroughbred

As these horses' heads
show, thoroughbreds and
workhorses differ in the
shape of their individual
parts as well as in overall
proportion. In each case, I
first did a drawing *(above*
and *below)* to establish the
basic shapes.

Note the thoroughbred's
full, rounded cheek,
narrowing down towards
the chin. Notice, too, the
deep dent in the underside
of its chin, and the straight
bridge of its nose.

Now compare this to the
workhorse's head. Note
the slightly rounded bridge
of its nose and its blunt-
ended snout, and how
there is no dent in its chin.

Head of a
workhorse

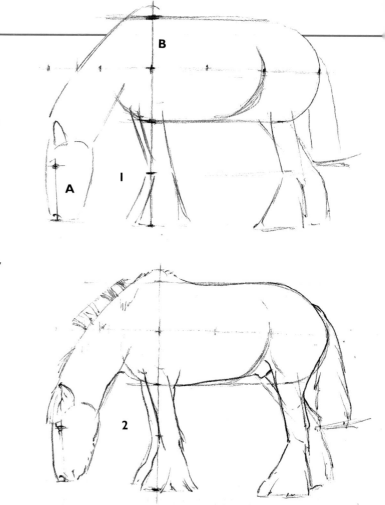

Workhorse breeds

Although workhorses are all generally heavy in build, there are distinctions even within this one category that mark one breed from another.

A workhorse's size, proportions and shape reflect the work it was bred to do. The Shetland, shown opposite, is a very small horse which originates from the Shetland Isles, where it was used for carrying peat and generally pulling carts. Because of the harsh climate of the Islands, it developed a thick coat and a long, thick mane and tail as protection against the weather.

The larger Clydesdale, shown on this page, was used successfully for haulage work at the coalfields, as well as heavy agricultural work.

Comparing size

Size is probably the most obvious difference between the breeds – to realize how great the range is, just compare a diminutive Shetland pony to an enormous Shire horse!

1 I drew this Clydesdale with a 2B pencil on medium-rough CS2 'not' paper. Using the length from eye to nostril (A) gave me a handy measuring unit, allowing me to work out the proportions quickly. Drawing a vertical line down through the shoulder (B) showed the backward slant of the legs.

2 When I was satisfied with the proportions of the basic shapes, I began to refine the drawing, adding more detail and erasing unwanted guide lines.

3 Finally, I completed the details and added shading to indicate the three-dimensional shape of the horse.

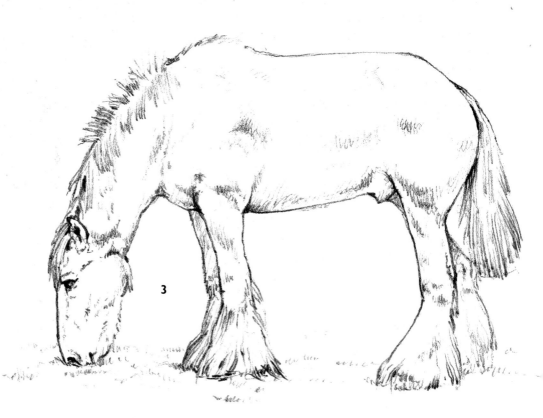

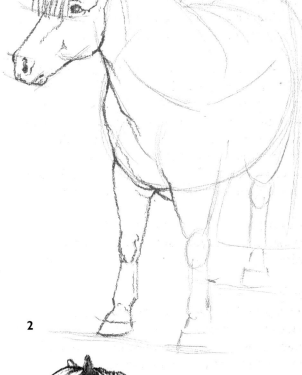

1

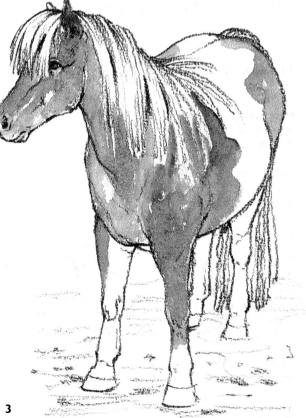

2

Comparing proportions

Proportions vary from one breed to another, too. For example, the proportions of the Clydesdale opposite are not dissimilar to those of the thoroughbred – although much heavier in build, *in proportion* its head is similarly small, and its neck and legs similarly long. By comparison with the Clydesdale, the little Shetland's head is relatively big and its legs relatively short.

Artist's Tip

The chinagraph pencil used for the Shetland pony on this page is almost impossible to erase so, if using chinagraph, do your basic drawing in soft pencil first.

1 To draw this Shetland pony, I first used a soft pencil to rough out the basic shape.

2 I then worked over the lines with a chinagraph pencil, adding details and erasing unwanted lines.

3 The final stage was to add a watercolour wash for the coloured areas.

3

Wild horses

The only genuinely wild horse is the Przewalski's, which roams areas of Mongolia, and was only discovered in the late nineteenth century. It stands about 1.2 metres (4 feet) tall at the shoulder and has a distinctive, stiff mane.

Zebras

A close wild relative of the horse is the zebra. There are three kinds, the largest being Grevy's zebra, which has numerous stripes over its whole body, with a broad stripe running down its back. The Burchell's zebra has broader stripes, but they are fewer in number and there may be none on its hind quarters. The smallest zebra is the mountain zebra, which measures less than 1.2 metres (4 feet) tall at the shoulder.

Working quickly

The distinctive markings of the zebra are probably its most attractive feature, but they can be time-consuming to copy. If you are working from a photograph, you will have no trouble in getting your subject to 'pose' for you for as long as you need. It is always preferable, though, to draw from life so you can have a direct experience of the living animal in front of you – in which case, you will probably be doing your drawing at a zoo.

Although a zoo complex will prevent your subject from running off, the animal will still be very much mobile and could remain in place for no more than a few seconds – so you will need to work quickly.

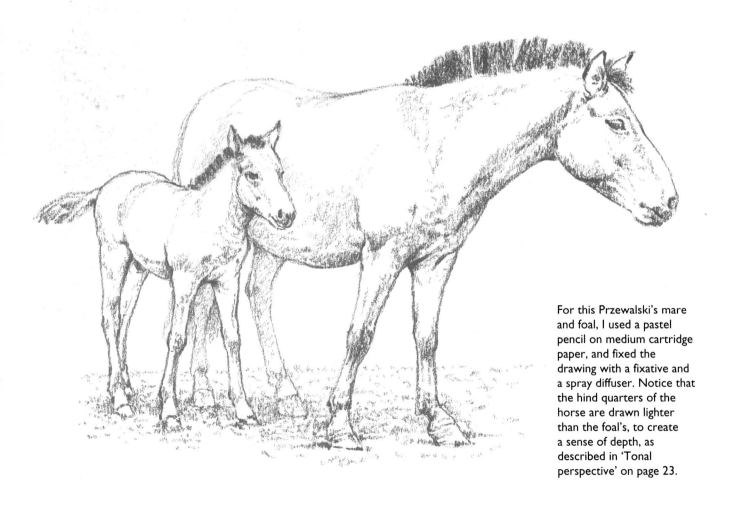

For this Przewalski's mare and foal, I used a pastel pencil on medium cartridge paper, and fixed the drawing with a fixative and a spray diffuser. Notice that the hind quarters of the horse are drawn lighter than the foal's, to create a sense of depth, as described in 'Tonal perspective' on page 23.

Building a framework

The important thing is to get down on paper a good framework of lines to build on. You may not have time to use a measuring unit to work out the proportions, so do this by eye, constantly comparing the sizes and angles of the various parts as you work, and giving just an indication of the directional pattern of the stripes. Once you have got the basic drawing right, you can add in the detail afterwards by carefully observing your subject.

I

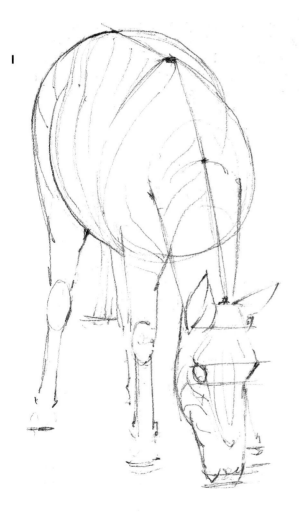

2

I Using a 2B pencil on watercolour paper, I quickly sketched in the main outlines and rough pattern of stripes of this drinking zebra.

2 I later completed the detail in watercolour. I added patches of paint below the zebra's nose and hooves to indicate its reflection in the water.

Light and Shade

Without light and shade, a drawing may remain just an outline shape, with no sense of three-dimensional form – as you can clearly see in the two diagrams below. Without shading, the ball on the left is just a circle, floating in space; add shading and it is instantly transformed into a three-dimensional sphere.

Experimenting with light
To understand the principles of light and shade, try to spend some time studying the effect light has on an object. The object you choose for your study could be anything but, to start with, a simple, rounded shape, such as a ball or round fruit, would be best.

Natural light cannot be controlled in the same way as artificial light, so do your experimenting indoors, initially using just a single table lamp or torch to avoid complicated shadows. Try moving the light around to different locations around the object, placing it close and then further away to see how this affects the *modelling* – creating three-dimensional form with shading.

Highlights and shadows
As well as giving a flat object three-dimensional form, light and shade also help to show where an object curves outwards and where it hollows. Essentially, light will *highlight* raised or prominent shapes facing the light. Sunken areas, on the side away from the light, will be in shadow.

Reflected light
By careful observation you will discover that light can behave in an unexpected way. For example, the area most hidden from the light source is not necessarily the darkest. This is because light may be reflected back on to the subject matter from surrounding surfaces, producing shadows of varying degrees of intensity. Within these shadows there may be lighter patches, or *low lights*.

Light may, of course, also come from more than just a single source, although this one source may be more powerful than others.

Variations in tone
Modelling a drawing of a horse is a perfect example of these subtleties in light and shade. Unlike a simple rounded ball or orange, a horse is a complicated shape, made up of a whole series of different curves and hollows.

To work out where the highlights, low lights and shadows fall, it helps to break your subject down into more basic forms. You will find many tones between the lightest and darkest areas, but you can simplify the exercise by just using, say, two or three tones: a dark one for the darkest areas, a mid-grey for the middle tones and white paper for those areas directly facing the light.

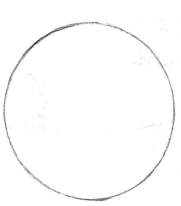

This drawing is no more than an empty circle, with no three-dimensional form.

Darkest areas

Reflected light

Light source

The same drawing, with the addition of shading, instantly becomes a solid-looking ball.

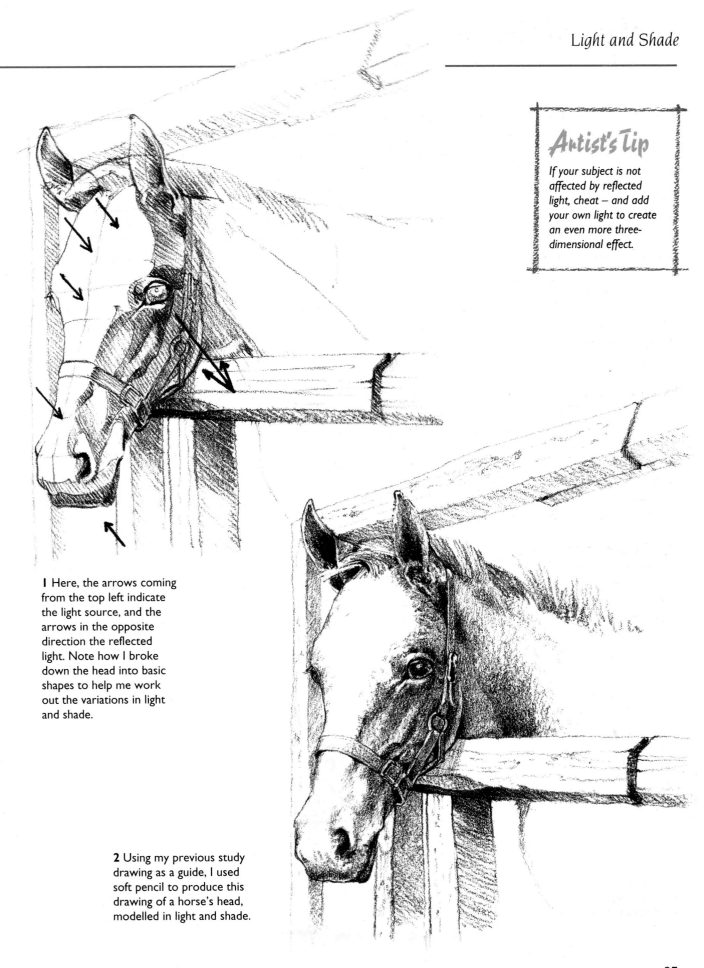

1 Here, the arrows coming from the top left indicate the light source, and the arrows in the opposite direction the reflected light. Note how I broke down the head into basic shapes to help me work out the variations in light and shade.

2 Using my previous study drawing as a guide, I used soft pencil to produce this drawing of a horse's head, modelled in light and shade.

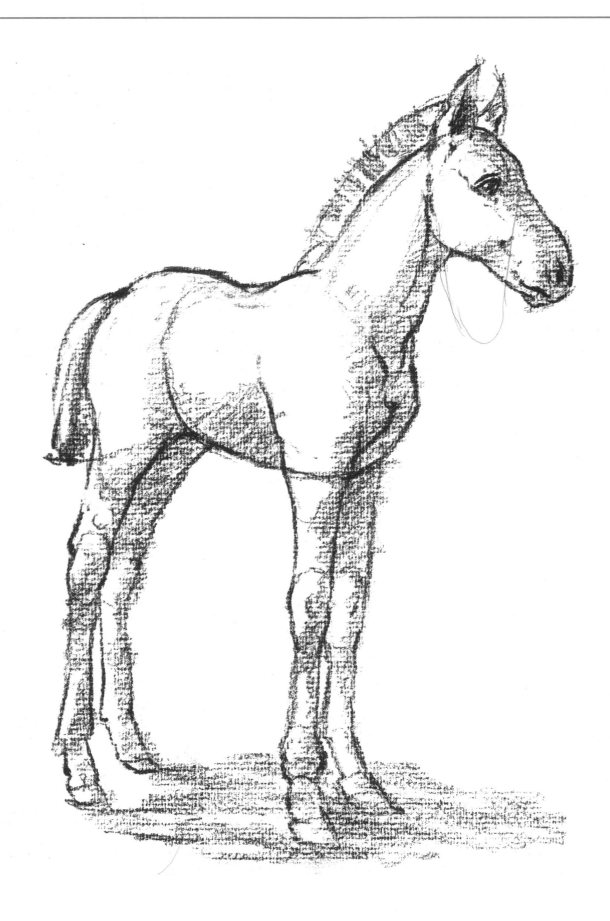

Changing light

If you are working in natural light – say, doing a sketch of a horse out-of-doors – bear in mind that the strength and direction of the light will change as time passes, and this will affect the intensity of the highlights and where the shadows fall. So that you don't have to keep amending your work, you might like, after drawing in your basic shapes, to make a mental note of the direction of the light source and lightly block in the shaded side as a reminder.

Cast shadows

Light also causes an object to cast shadows on to other objects or surfaces. This can become complicated if for some reason the light is coming from two or more different sources. When this happens, one light could cancel out part, or all, of the shadow cast by the other light, as illustrated in the diagrams below. Make sure, therefore, when you are drawing specifically to study shadows, that the light comes from one source only.

Shapes and angles

Look carefully at the angle at which the shadow falls in relation to the direction from which the light is coming.

Look also at the shape of the shadow. A shadow is never exactly the same shape as the object casting it, but a distorted version. The position of the light source will affect the length of a shadow: for example, a sun high in the sky will create short shadows, while a low sun creates elongated ones.

The surface on which a shadow falls also changes its outline. A relatively even surface, such as a wooden floor, will produce a fairly smooth outline; a rough surface, such as grass or stony ground, will break up a shadow, producing a jagged, patchy shape.

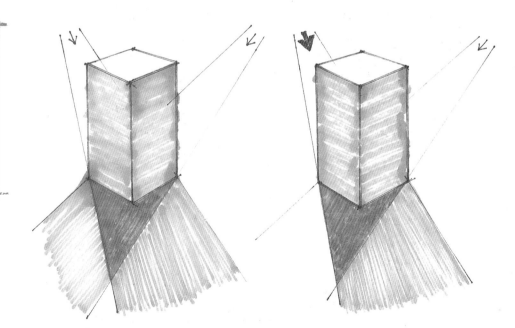

Artist's Tip

If your subject appears to be floating in space, 'anchor' it to the surface on which it is sitting or standing by adding a little shading underneath.

I did this drawing of a foal *(opposite)* on Ingres paper, using conté crayon. Here, the light is coming from above and slightly to the left, creating shadow on the right and underneath the animal. Although the shadow on the ground does not strongly echo the foal's shape, notice how important it is in linking the animal firmly to the surface.

These two diagrams show the possible effects of light from two different sources. In the diagram on the left, both lights are of equal strength and soften part of the shadow cast by each other. Only the central shadow, which neither light can reach, remains dark.

In the second diagram, the light on the left is stronger and obliterates part of the shadow cast by the light on the right.

37

Texture and Markings

To portray the various textures and markings on a horse effectively calls not only for skill but also for knowledge of the effects that different media produce. The more you practise and experiment with different media, the greater your knowledge and skill will be. You will then find it easier to choose the most appropriate materials to create the effect you want. You will discover, too, that there is more than one way to achieve a particular texture.

1 These two drawings show how to achieve a smooth effect with pencil. First do your pencil drawing (*above*), adding gentle shading where required.

2 Then smudge the shading with cotton wool, your finger or a French stick (*below*). Notice how smudging makes the shading darker. If you find that some areas are too dark or hard-edged, dab them with a putty eraser.

1 I discovered this technique by accident, when I placed a wet hand on a felt-pen drawing. It is ideal for conveying the silky smoothness of a horse's coat. Begin by doing a simplified drawing in felt-pen (*above*).

2 Then dip a brush into clear water to make it damp but not too wet. Run the tip of the brush along the inside of the lines only, to dissolve the ink slightly and create a shaded effect (*below*). This technique works best on paper or board with a smooth surface.

Contrasting textures

One of the most obvious contrasts in surface texture is that between the 'streaky' appearance of a horse's mane and tail and the sleek smoothness of its coat. There are various ways you could convey these effects. For example, you could use pencil for both, but choose a dark, soft B grade for the hair, and a light, hard H grade for the body. Or you could use the same pencil for both areas, but soften the effect by gently rubbing the body area with a finger, wad of cotton wool or cotton-tipped bud, or even a French stick or 'dubber' (a specialist tool designed for smudging soft media such as pastel and charcoal).

Alternatively, you could use a delicate watercolour wash over the body area, and dark brush-strokes over the mane and tail.

To achieve the wonderful speckled pattern on this Percheron, I first shaded in the entire horse's body in pastel pencil, then picked out the spots by dabbing with a putty eraser.

Another way to create a similar effect would be to dab on spots of masking fluid, then paint over the whole with an ink or watercolour wash. The masking fluid can then be removed to reveal light patches underneath (although these will be harder-edged than those created by the eraser).

Artist's Tip

Creating a sense of texture is to do with 'seeing' what something feels like. So, when working out what effect to create, imagine you could touch your subject. Does it feel smooth and velvety? Coarse and rough? Choose your materials accordingly.

Behaviour and Expression

On the whole, horses are very sedate creatures – one has only to observe the control a small girl has on an animal that dwarfs her in size, weight and strength to realize this. Nevertheless, there are times when horses show emotion, ranging from tenderness through to sheer joy and excitement.

While out walking one day I saw an owner release his horse into a small field. The horse immediately took off and galloped around the field for a while and then got down and proceeded to roll back and forth on its back. You could clearly see the exuberant sense of liberation felt by the animal.

Photographic reference

It would be almost impossible to capture such behaviour on paper, as it was happening. Apart from having to draw extremely quickly, the odds on being in the right place, at the right time, and with the right equipment must be astronomical. This is where a camera can be an invaluable tool. I have seen numerous photographs showing just this situation, as well as similar nature and wildlife video recordings. (Making use of these is dealt with on pages 62-63.)

Odd angles

Even with the help of photographic reference, however, this type of behaviour can be difficult to portray convincingly because horses are not normally seen from these angles and, when they are, have a tendency to look odd. If you practise drawing from different and unusual viewpoints, you will become more familiar with the whole shape of the horse – not merely the familiar front and side views – and more confident in portraying such 'quirky' poses.

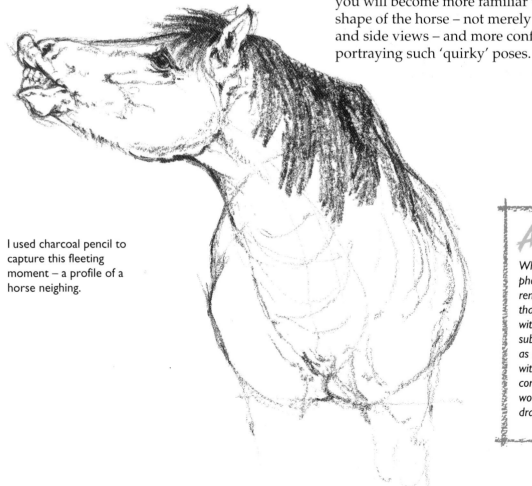

I used charcoal pencil to capture this fleeting moment – a profile of a horse neighing.

Artist's Tip

Whenever you use photographic reference, remember, as always, that you are dealing with a three-dimensional subject and construct it as such, building it up with guidelines and contour lines, as you would if you were drawing from life.

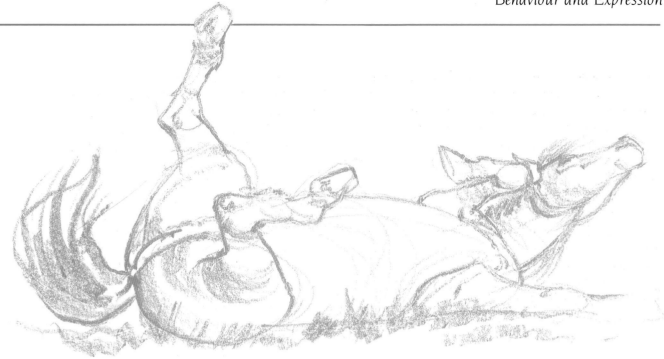

When drawing 'action' situations, try to use a freely flowing medium that will allow you to work loosely, producing a fluid line that conveys a sense of movement. Work quickly, even when drawing from photographs. For these two rolling horses *(above* and *below)*, I chose a broad, chisel pencil.

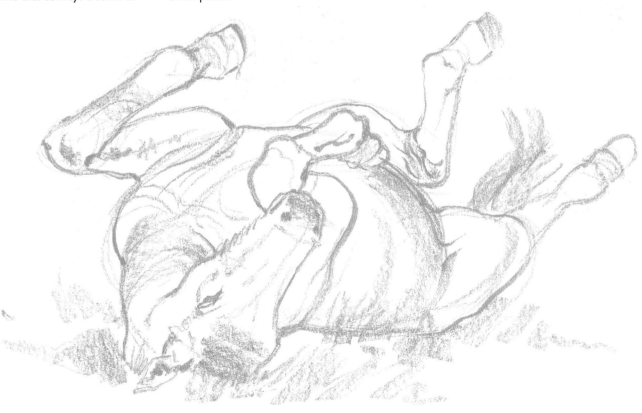

Horses grazing

If you prefer to start with something less challenging than a horse rolling about on the ground, a horse in the process of eating – whether from a trough or bag, or grazing – would be a good choice. An animal feeding from some form of container would be ideal because, apart from the head, there would be little or no movement in the body. This would give you time to choose your viewpoint and either do one carefully measured drawing, putting in as much detail as possible, or two or three quick sketches from different angles.

There is more movement in a grazing horse, but it is very slight, giving you an excellent opportunity to do a series of sketching studies.

Flexible medium

Because of its flexibility, watercolour is an excellent medium to choose for depicting horse behaviour. It is a medium which I enjoy using a great deal, and has an aesthetic quality which I like very much. You can be very exact with it, keeping it tight to produce realistic, detailed work, or use it loosely to produce fresh, free-flowing work. I have also used it in combination with coloured pencils to sharpen up the details on a drawing.

This horse was drawn from a photograph, using watercolour. I first lightly drew the shape, putting in just the bare amount of information I needed: I didn't want to overwork the drawing because I wanted the freedom to draw with the brush as I painted. Although I had plenty of time because I was drawing from a photograph, I worked quickly as if I expected the animal to move at any moment.

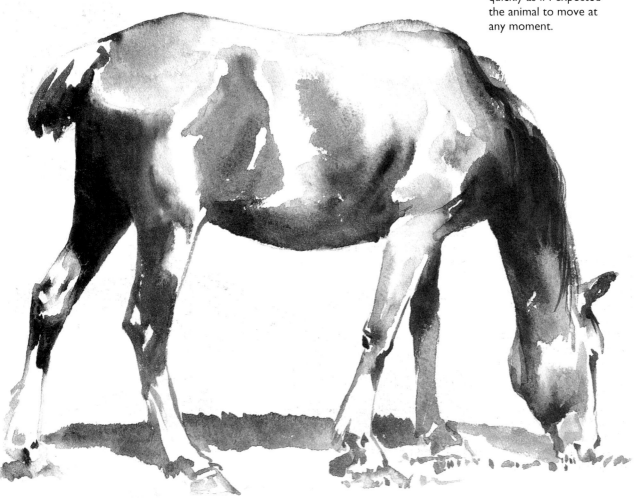

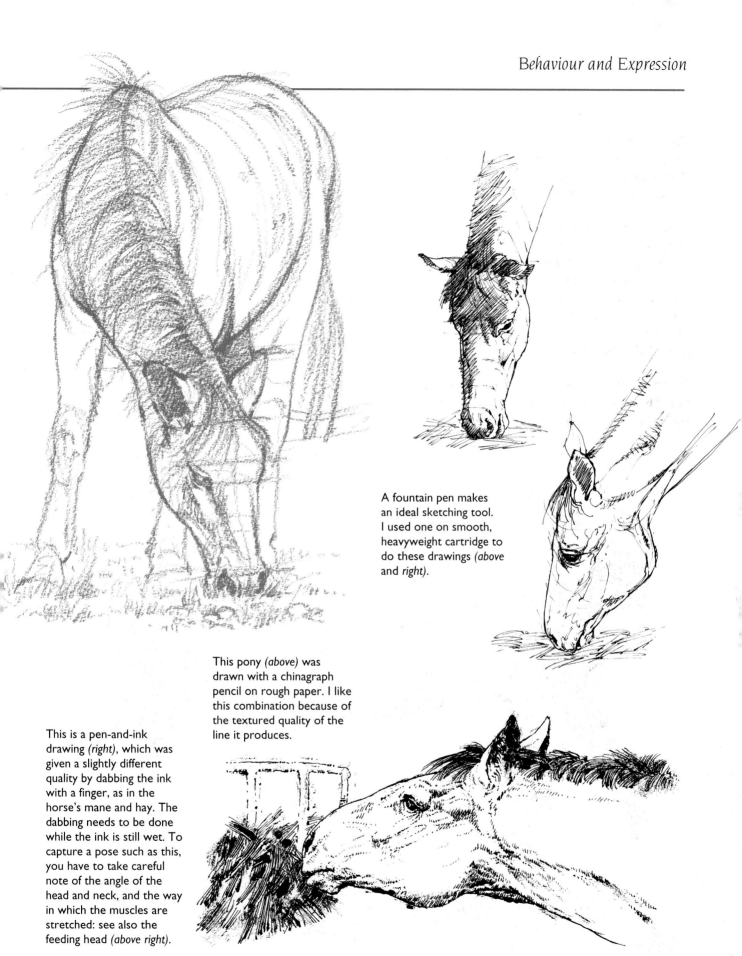

A fountain pen makes an ideal sketching tool. I used one on smooth, heavyweight cartridge to do these drawings (above and right).

This pony (above) was drawn with a chinagraph pencil on rough paper. I like this combination because of the textured quality of the line it produces.

This is a pen-and-ink drawing (right), which was given a slightly different quality by dabbing the ink with a finger, as in the horse's mane and hay. The dabbing needs to be done while the ink is still wet. To capture a pose such as this, you have to take careful note of the angle of the head and neck, and the way in which the muscles are stretched: see also the feeding head (above right).

Working from life

When first drawing horses 'in action' outdoors, limit yourself to one medium only. For example, if you choose to work in pencil, take only one medium pencil (say a B), a sharpener and, of course, a sketchbook. You will not need an eraser: if you feel you have made a mistake by drawing a line in the wrong place, simply draw it again in the right place. You can erase the incorrect one later, if necessary, but I would leave it, for it will show you where you went wrong and how you corrected it.

You can add to your outdoor equipment as you gain experience and become more confident about working out on location. In the meantime, however, avoid cluttering yourself up with unnecessary tools until you have tried out different media and know which ones you like.

Showing expression

As well as the more active ways of behaving, in their quieter moments horses are also capable of revealing mood and emotion, as careful observation of them will show. Look, for instance, at the two examples here. The mare feeding her foal on the opposite page has a gentle, peaceful expression on her face, while the horse in the drawing below, with its lowered head and eyes, could not look more weary.

I decided to draw this weary character in pastel, which I thought suited the sombre mood. I lightly drew the head using a light pastel pencil, just enough to establish the shape and indicate the position of the features. I then began adding the darker tones, gradually working up to the lighter ones.

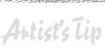

If you have overworked a pastel drawing by placing too many colours on top of each other, spray the area with fixative. When this dries, you will be able to work over your drawing again without difficulty.

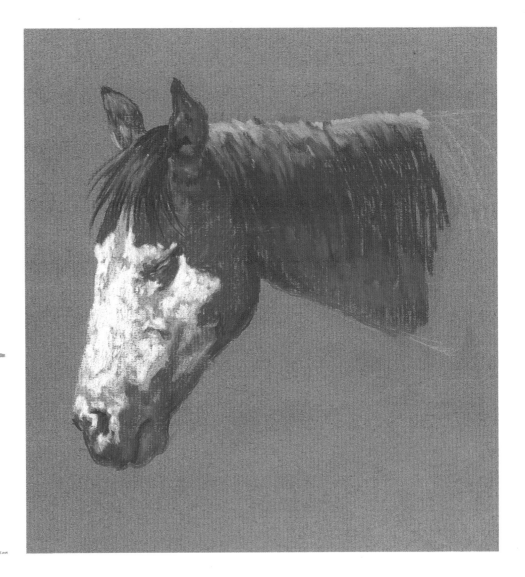

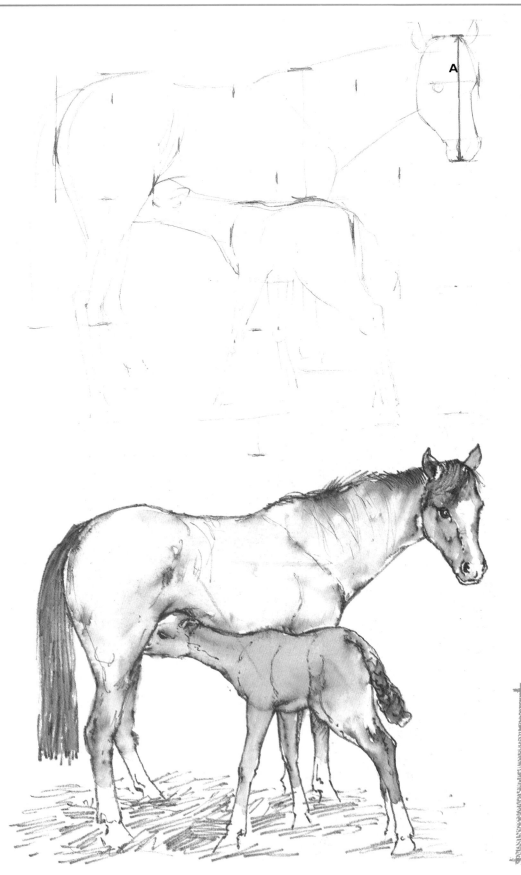

A tender scene, not often witnessed but one that would be a welcome addition to any portfolio. I first drew the basic shape. Then, using the length of the head (line A) as a measuring unit, I quickly checked the accuracy of the proportions. This basic drawing was done with a 2B pencil. The sketch was then overdrawn with a felt-pen, and the pencil lines were erased before applying a wash of clean water. If using this technique, wait until the work is completely dry before sharpening up any lines that have faded under the wash.

Artist's Tip

Don't throw away your old felt-pens until they are completely dry and unable to make a mark – dryish felt-pen produces a subtle and interesting line.

Movement

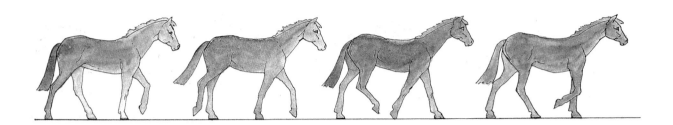

It would be impossible literally to draw a running or jumping horse from life: it simply moves too quickly for the eye to follow. Although its head and torso remain relatively static, the position of its legs is constantly changing and, in fact, follows a strict sequence made up of a whole series of small, individual movements, rather like the frames in a cartoon film. All this happens too fast for the human eye to capture – but not for the lens of a camera.

These two sequences (*above* and *above right*) show the series of movements a horse goes through when walking and when running. As an experiment, you could try adding further horses to each sequence to complete the series of movements – about two more in each case should be enough.

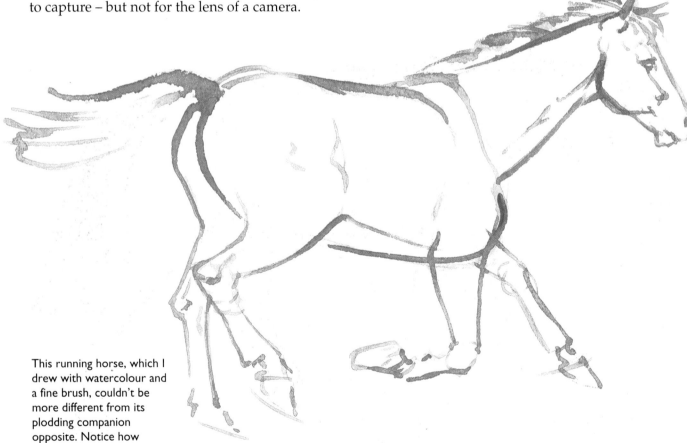

This running horse, which I drew with watercolour and a fine brush, couldn't be more different from its plodding companion opposite. Notice how its head is held up high, and how its tail flicks out behind, as if caught by the wind. As well as being an accurate portrayal of the horse's pose at this moment in time, the angle of its neck and tail helps to create a sense of powerful forward movement. The upper outline of neck, back and tail in fact form one long, continuous, fluid line, like a forward-pointing arrow.

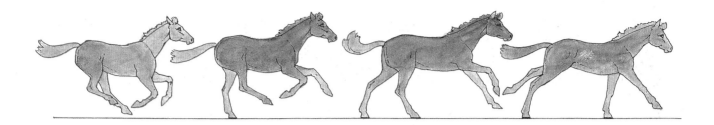

Freeze-frame

Before the advent of photography, people simply had to guess at how a horse's legs moved – which accounts for the rather strange-looking paintings that you may have seen in art galleries, in which the horses appear to be leaping along in mid-air, with all four legs stretched out at the same time.

With the help of photographs and early film, people were, for the first time, able to 'freeze' these sequences of horses in movement, and so see exactly what was happening: when the legs bent, when they stretched out, when they touched the ground, and – perhaps most importantly – how these separate movements all synchronized.

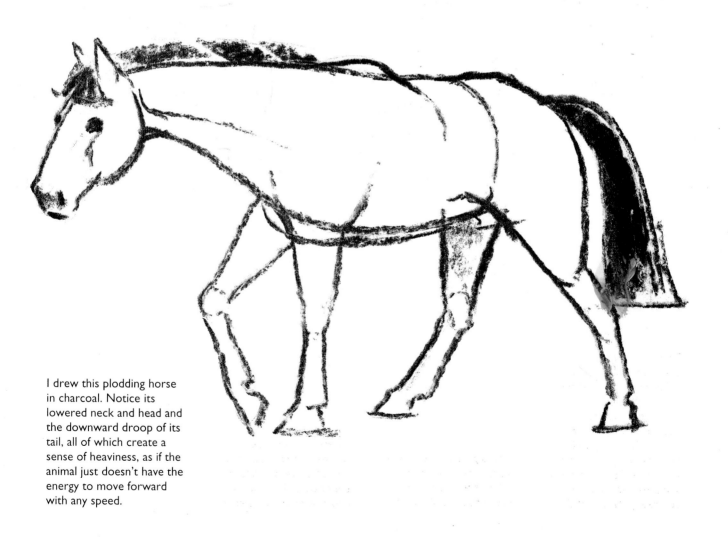

I drew this plodding horse in charcoal. Notice its lowered neck and head and the downward droop of its tail, all of which create a sense of heaviness, as if the animal just doesn't have the energy to move forward with any speed.

Working from memory

If you are drawing from life, the best method I have found is to spend some time simply observing your subject. Then, while the information is still fresh in your mind, quickly put down on paper everything that you can remember.

Capturing the essentials

Regard what you are doing as an exercise. The purpose of the exercise is not to produce a perfect drawing, but to capture the essence of the horse's body movement. What you are looking for are the *rhythms* in the body – the flowing sweep of lines and angles. If you can get these down first, concentrating just on the basic shapes, details can always be added later if required.

Speed and size

In order to avoid getting too bogged down in detail, it's best to draw quickly. To help you to get as much movement into your lines as possible, you will also need to draw large. This will give you the freedom of movement to produce the 'action' lines. I would stress, however, that you should choose a scale with which you feel comfortable: if you force yourself to draw unnaturally large, this will only inhibit rather than liberate your style.

This energetic conté drawing is a perfect example of how to convey movement with just a few broad strokes. The artist has not concerned herself with irrelevant detail, but has worked loosely, focusing on the main rhythms in the body.

Artist's Tip

When trying to get movement into your lines, don't force the pace but draw as quickly as you comfortably can. With practice, you will automatically begin to draw faster and with greater confidence.

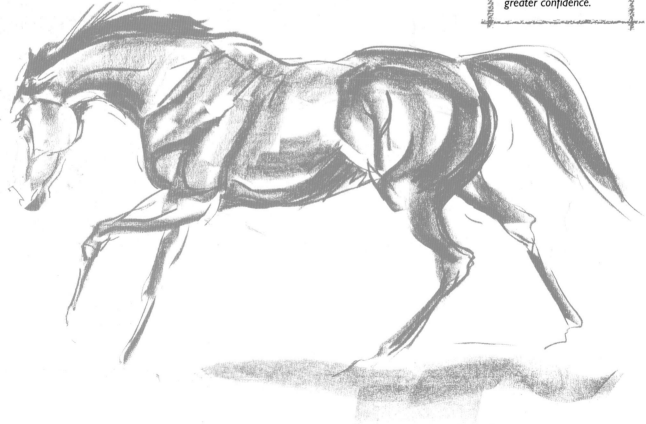

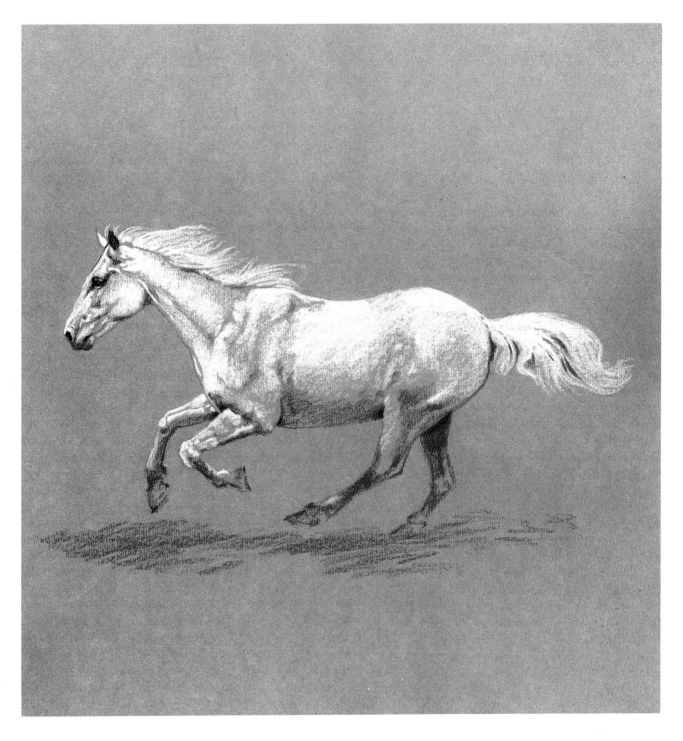

This running horse shows how the basic movement can be captured on paper first, and then detail worked in at a later stage. For this drawing, I used only two pastel pencils for the basic tones, with just a touch of black here and there. The middle tone is created by the colour of the Ingres paper into which I have graded the white and grey pastels.

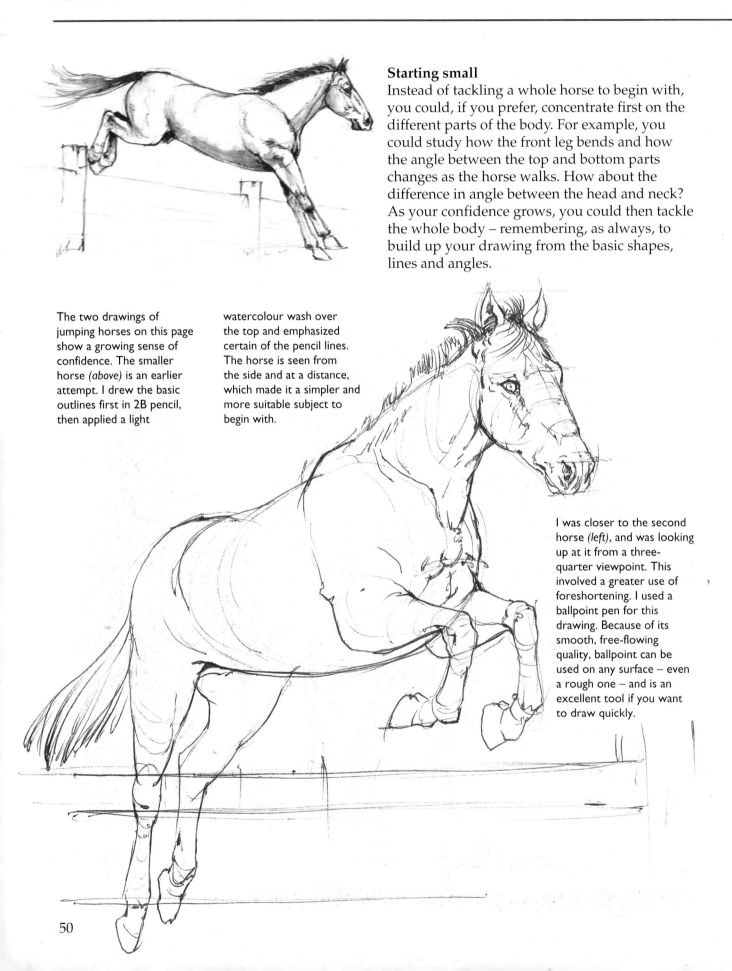

Starting small

Instead of tackling a whole horse to begin with, you could, if you prefer, concentrate first on the different parts of the body. For example, you could study how the front leg bends and how the angle between the top and bottom parts changes as the horse walks. How about the difference in angle between the head and neck? As your confidence grows, you could then tackle the whole body – remembering, as always, to build up your drawing from the basic shapes, lines and angles.

The two drawings of jumping horses on this page show a growing sense of confidence. The smaller horse *(above)* is an earlier attempt. I drew the basic outlines first in 2B pencil, then applied a light watercolour wash over the top and emphasized certain of the pencil lines. The horse is seen from the side and at a distance, which made it a simpler and more suitable subject to begin with.

I was closer to the second horse *(left)*, and was looking up at it from a three-quarter viewpoint. This involved a greater use of foreshortening. I used a ballpoint pen for this drawing. Because of its smooth, free-flowing quality, ballpoint can be used on any surface – even a rough one – and is an excellent tool if you want to draw quickly.

If you practise this system, eventually your observation, understanding and memory will improve sufficiently to enable you to reproduce most of the body shapes.

You can practically hear the racehorses thundering towards you in this dynamic pencil drawing *(below)*. The tremendous muscular strength and power of these animals is heightened by the dramatic foreshortening of their bodies, which makes them appear wider and bulkier. The bold, diagonal lines made by the pencil further enhance this effect.

Varying the angles

When you feel more confident in portraying movement, try drawing horses from different angles – perhaps seen from slightly below as a horse jumps a fence, as in the drawing on the opposite page; or even galloping straight towards you, as in the dramatic drawing of racehorses below.

To be able to produce drawings like these involves an understanding and knowledge of foreshortening (see pages 22-23).

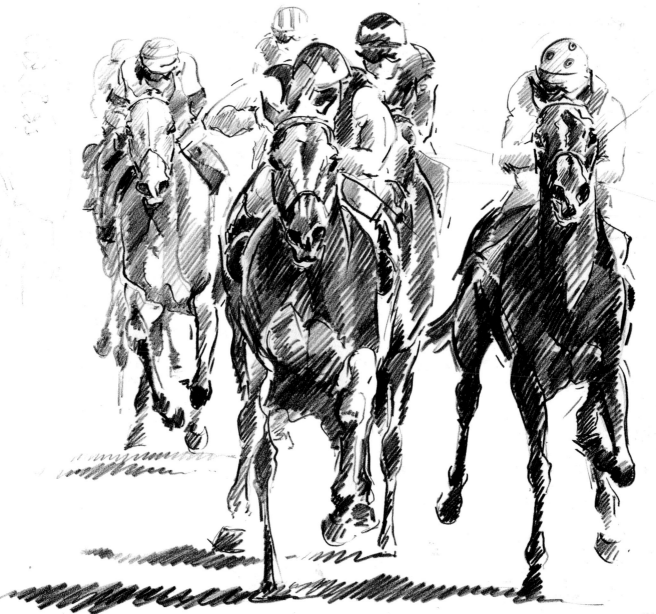

Sketching

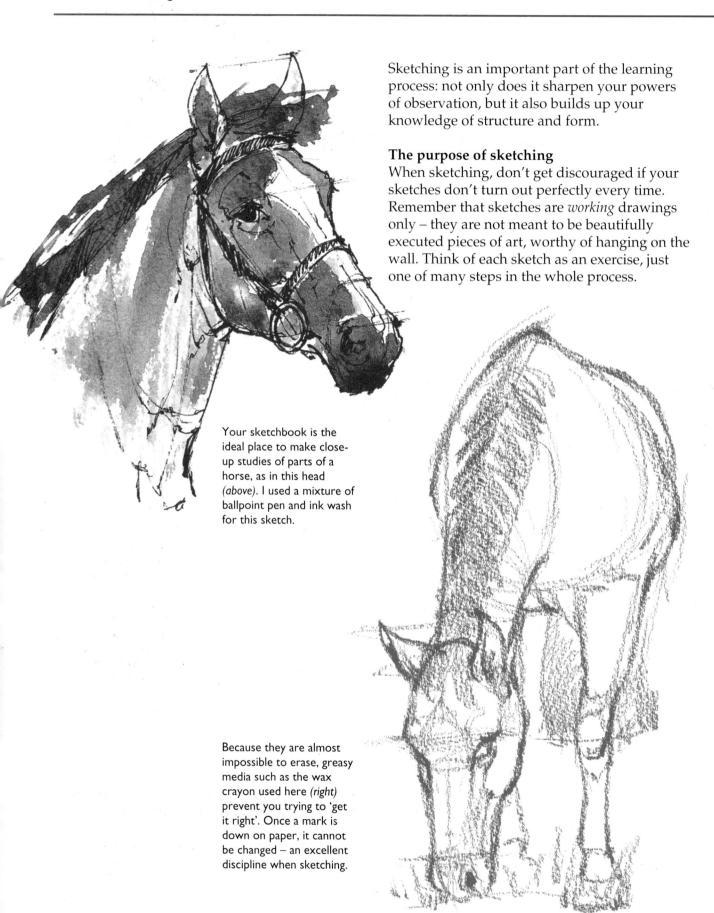

Sketching is an important part of the learning process: not only does it sharpen your powers of observation, but it also builds up your knowledge of structure and form.

The purpose of sketching
When sketching, don't get discouraged if your sketches don't turn out perfectly every time. Remember that sketches are *working* drawings only – they are not meant to be beautifully executed pieces of art, worthy of hanging on the wall. Think of each sketch as an exercise, just one of many steps in the whole process.

Your sketchbook is the ideal place to make close-up studies of parts of a horse, as in this head (*above*). I used a mixture of ballpoint pen and ink wash for this sketch.

Because they are almost impossible to erase, greasy media such as the wax crayon used here (*right*) prevent you trying to 'get it right'. Once a mark is down on paper, it cannot be changed – an excellent discipline when sketching.

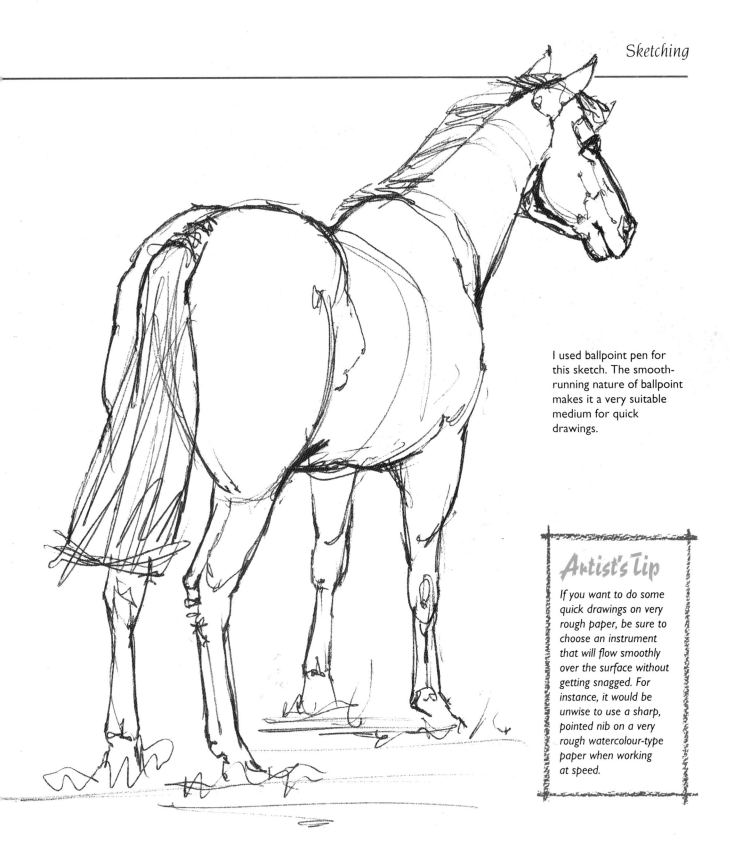

I used ballpoint pen for this sketch. The smooth-running nature of ballpoint makes it a very suitable medium for quick drawings.

Artist's Tip

If you want to do some quick drawings on very rough paper, be sure to choose an instrument that will flow smoothly over the surface without getting snagged. For instance, it would be unwise to use a sharp, pointed nib on a very rough watercolour-type paper when working at speed.

Styles of sketching

Sketching can take various forms. You may, for example, use your sketchbook to make quick scribbled drawings in an attempt to capture movement. Alternatively, you could do detailed drawings of various parts of the body to be used for future reference, thereby improving your knowledge of anatomy. You could also combine sketching with experimenting with different media and techniques.

Learning to select

To improve your powers of observation and selection, practise this system. First, use your eyes to study the horse, taking note of the basic shapes and angles; then, when it's still fresh in your mind, quickly draw as much as you can remember without looking up again until you have drawn every bit of memorized information.

By drawing from memory in this way, you will realize what information you need in order to make a presentable drawing and – just as important – what to leave out. When you come to repeat the exercise, you will then be more experienced as to what to look for and record.

In no way is this a finished drawing *(left)*, but it contains all the basic information you would need about structure, form and foreshortening to enable you to work up a more detailed piece.

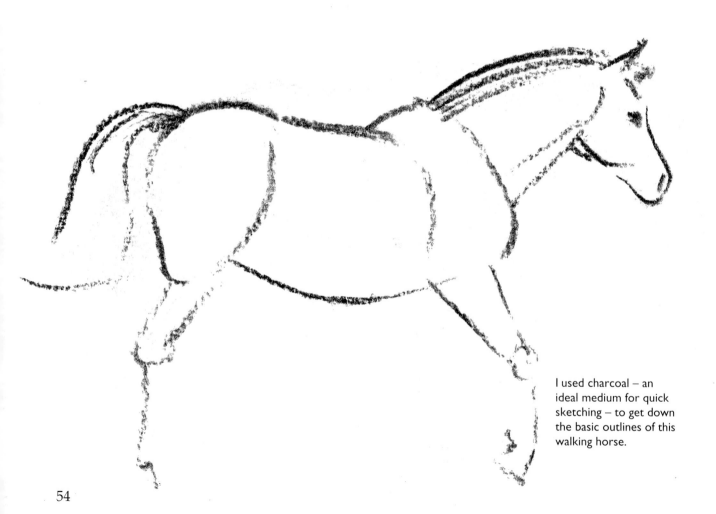

I used charcoal – an ideal medium for quick sketching – to get down the basic outlines of this walking horse.

Good practice

Try to get into the habit of carrying a sketchbook and drawing tools around with you whenever you can – this is good artist's practice. Then, should you unexpectedly spot something you would really like to get down on paper, you will have everything you need at hand. Doing frequent sketching is a sure way to improve your drawing skills.

The drawings you do in your sketchbook can also provide invaluable reference when you are unsure of what a particular feature looks like, and need more information.

Artist's Tip

Never throw away or destroy your old sketchbooks. They could be of some help to you at a later date, and will also be a fascinating indicator of how your drawing is progressing.

Smudging charcoal is a useful, quick technique for 'blocking in' certain areas, such as this horse's mane and tail.

So that they don't become too smudged, try to fix your charcoal sketches as soon as possible after you have done them.

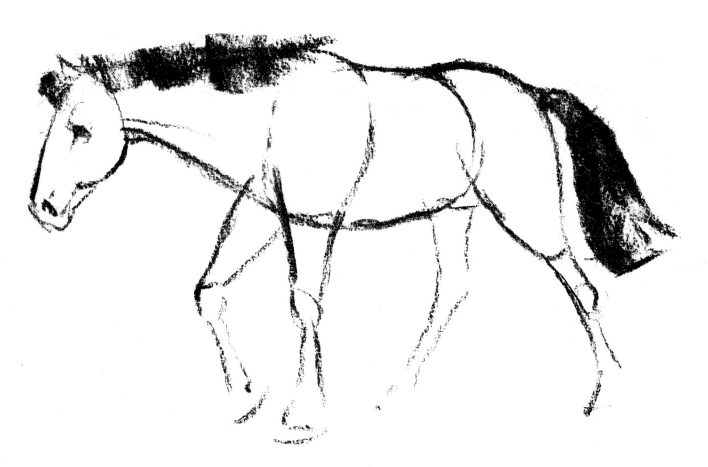

Framing and Composition

Composition is a word used to describe the arrangement of various elements so that they produce a balanced picture which is pleasing to the eye. When piecing these elements together, it would be helpful to bear in mind a few of the general rules of composition.

'Framing' your subject or composition *(right)* is a useful technique when deciding on your arrangement. First cut out two corners from card, as long as you want, then turn them into a frame by holding them together at right angles.

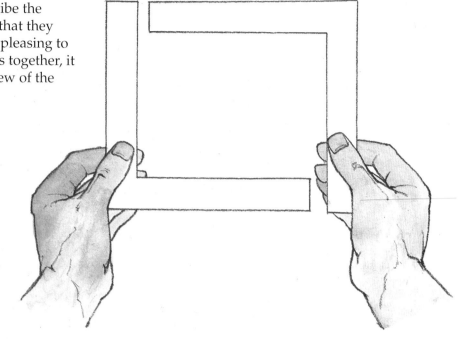

By sliding these two pieces together or pulling them apart *(above)*, you will be able to vary the size of the area surrounding your subject. Laying down a larger version of the corners over your finished drawing will also help you to decide on the size and proportions of your mount and/or frame.

Deciding what to include

When composing your drawing, you don't have to include everything you see. For example, you may, after studying a group of horses, decide to leave out one or more because doing so would improve the composition. You may even consider moving a horse to a different position. This is not 'cheating' – on the contrary, it is being creative, and may make the arrangement more interesting or even exciting.

The same principles apply when drawing a single horse. You could omit or underplay certain areas in order to concentrate on one particular part, such as the head.

The focal point

Every composition should have a focal point. This is the area to which the eye is drawn, because of its special visual quality, or because of the arrangement of the other elements in your picture.

Let me give you a simple example. Imagine that you are looking at a group of horses in close proximity to each other. They are almost all dark

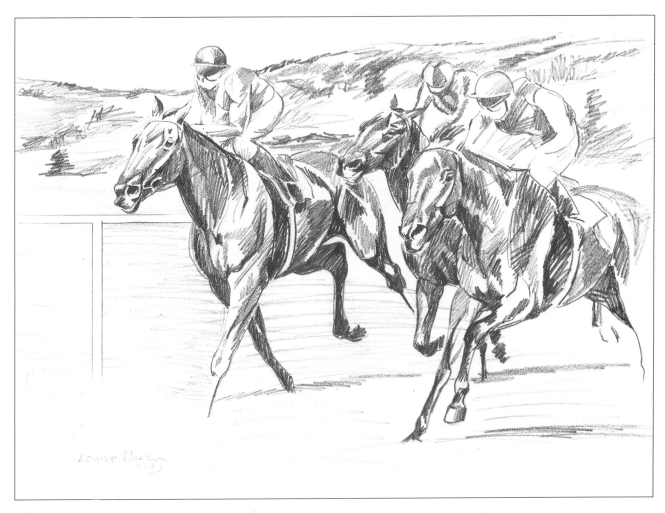

in colour – some black, some brown – but among them is a white or light grey horse. Your eye will be drawn to this horse, making it the 'focal point' of the group.

If this horse is at the very edge of the group, this would make for an uncomfortable arrangement, so it would be better either to move it to a more central position, or turn it into a dark-coloured horse and make one of the others a light one.

Off-centre
By suggesting that you move the horse further into the picture, I don't necessarily mean literally into the centre. This would be too obvious. Your picture would look more interesting if the horse were positioned slightly to one side, below or above the centre.

The spaces in front of and below this group of horses are an important part of the composition. Check this out by laying pieces of paper over the spaces to see what happens. You will notice how, without these empty areas to 'move into', the forward movement of the horses would be blocked.

Artist's Tip

Never accept immediately the arrangement you see in front of you. Try looking at it from another position or, if you have a group formation, study it to see if there is a better composition contained within the group. Use the framing method to help you.

In Setting

When producing study drawings, it is understandable to focus your attention on the horse alone; you might also do the same if producing the occasional drawing to frame and display on the wall.

Continuing to limit your subject matter in this way would, however, become very boring – to 'complete the picture', you should place your horse in its setting.

One of the most common settings in which you will find horses is with their riders. Horses and riders together may be found at riding schools, at the races or, as here, on the polo field.

Finding your location

There are many places you can go to find horses in different settings. For example, there are riding schools and stables scattered all over the country, which you could look up in a local directory. A polite phone call requesting a short visit to do a little sketching or photography may prove successful. Alternatively, you may know someone who is having riding lessons who could introduce you to the owner of the school – or, better still, you may even have a friend or acquaintance who actually owns a horse.

If you are unable to get such direct access to your subject matter, you may know of a field near you where horses frequently graze. Attending agricultural shows or race meetings would provide other sources of material and – if all else fails – there is always the local library; but do try to work from life if at all possible.

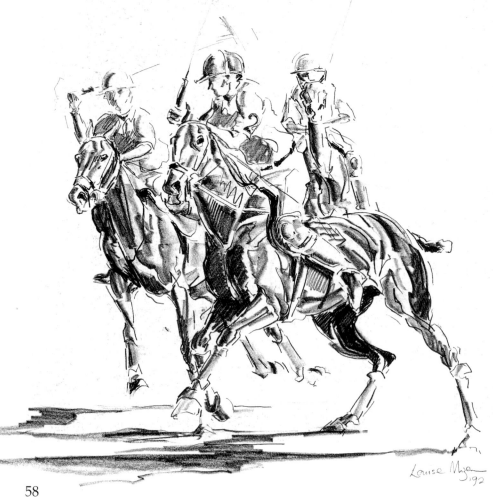

For this drawing of a horse gazing out above a stable door *(opposite)*, I used pastel pencils on Ingres paper. This paper can be bought in the form of a flip-over pad, in various sizes, making it convenient to carry about.

When doing the drawing, I concentrated on the horse itself, putting in a lot of detail, but kept the surrounding area light so that it wouldn't overpower the head.

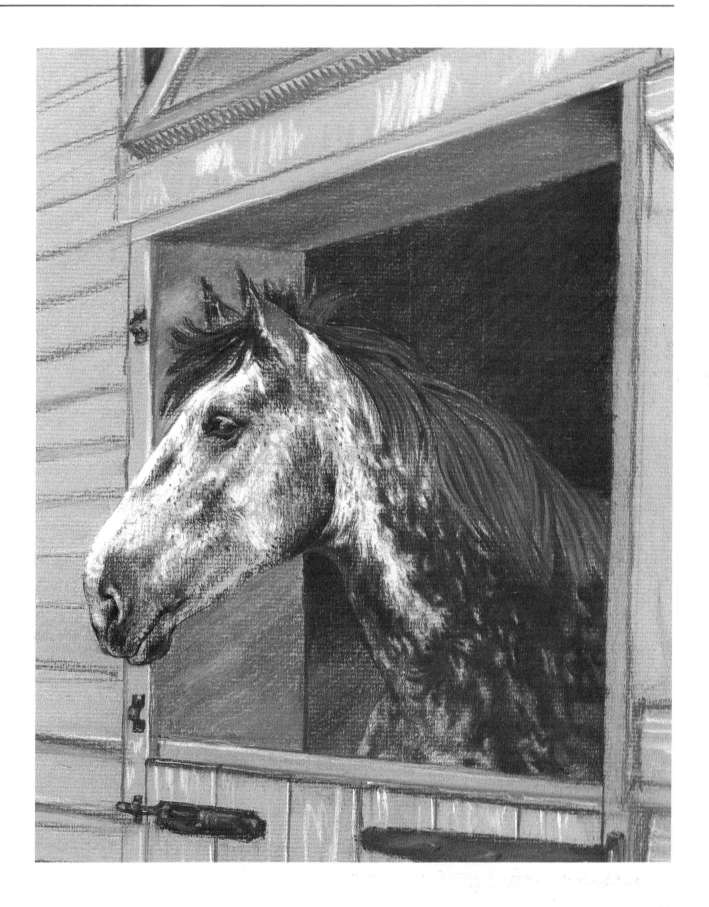

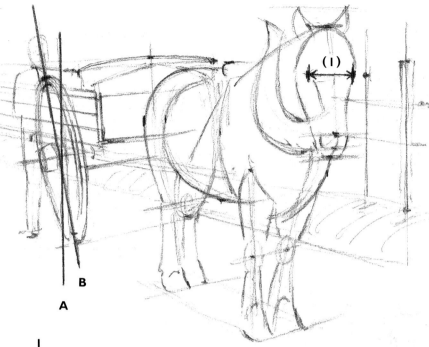

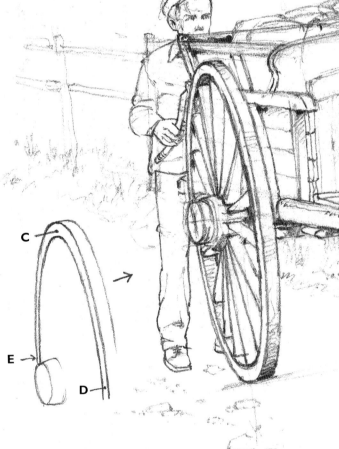

1 To draw this workhorse and cart, I chose the distance between the eyes (1) as my measuring unit, to check the accuracy of the proportions before adding any detail. To check the angle of the wheel, I held my pencil vertically (line A) to find how acute the angle was (line B).

Thinking about safety

When doing location work, always bear safety in mind. Listen to any advice given you as to where you should and should not go, for, apart from the possibility of an accident with the horses themselves, there may also be machinery or moving vehicles in the vicinity.

Objects in perspective

Just as the body of a horse is subject to the rules of perspective (see pages 20-23), so are the objects that surround it, and this is something you may have to tackle when drawing a horse in a particular setting. The cartwheel in the drawing on the right is a good example.

Seen from this angle, the wheel forms an *ellipse*, or flattened circle. If you look at the diagram of the wheel that accompanies the finished drawing, you will see that the side of the wheel at C appears wider than it does at D. This distortion occurs because you are looking at a perspective view of the wheel – in other words, you are looking *along* the side of the wheel at C, but *across* it at D, which creates a foreshortened effect and makes the outer surface of the wheel at D appear narrower than it really is.

Surrounding objects, such as the fence and the verge of the road, gave me extra reference points for cross-checking the position of key features, and for working out the perspective angles – note the perspective lines drawn across the horse's legs, and along the road and fence.

2 When I was happy that the basic outlines, angles and perspective were correct, I was able to erase unwanted marks and add in detail. Although the horse is, in reality, larger than the driver, the disparity in size appears greater here because of the distorting effects of perspective.

Artist's Tip

Always take along some cover paper and sellotape with you 'on location'. Then, instead of having to use fixative, cover your work with the paper, held in place on four sides with strips of sellotape, to protect it until you can spray it.

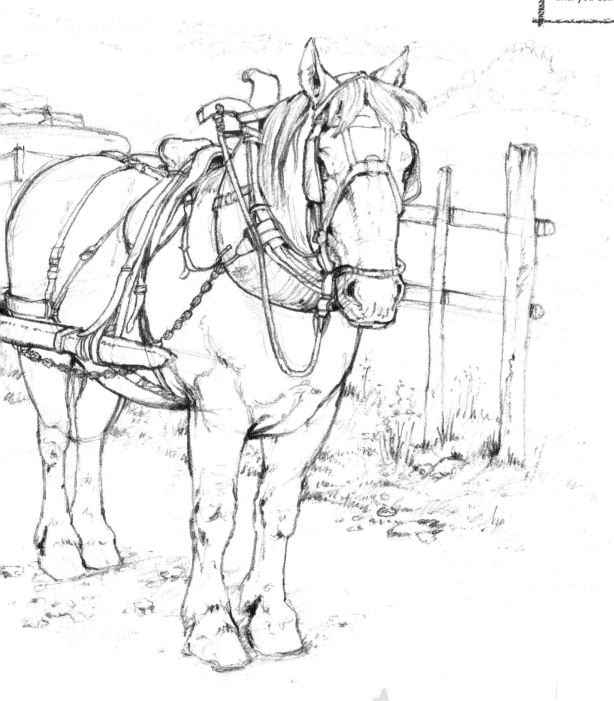

Working from Photos

Not many people are fortunate enough to live in a house overlooking grazing fields, or to have stables or a riding school nearby that would provide opportunities for location work. There are also many situations which would be impossible to capture when drawing from life. This is when photographs can be a really useful aid – just think of all those exciting action shots!

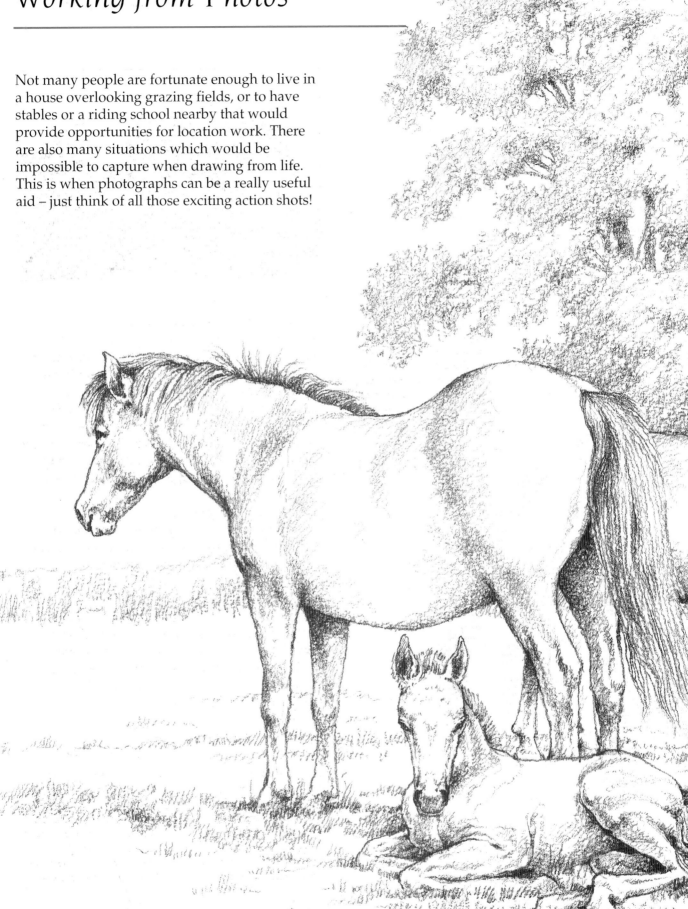

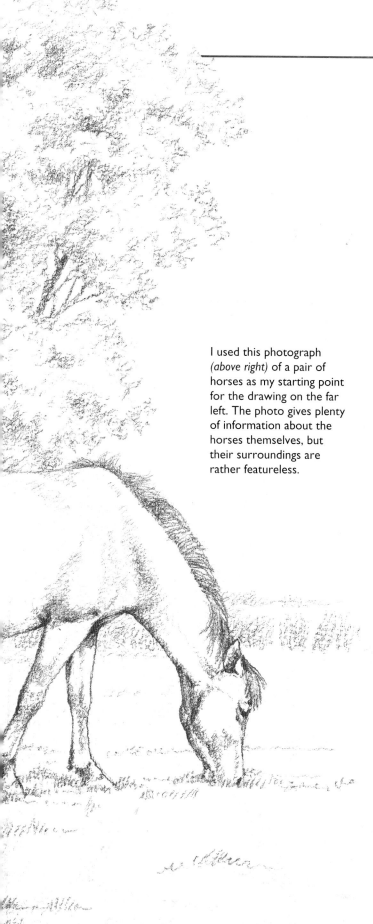

I used this photograph *(above right)* of a pair of horses as my starting point for the drawing on the far left. The photo gives plenty of information about the horses themselves, but their surroundings are rather featureless.

Thinking in three dimensions

Always choose a good-quality photograph whenever possible, and try to avoid copying it slavishly – remember that you are drawing a *three-dimensional* animal. Some photographs, particularly bad ones, have shadows which appear as flat, black areas, but you should not draw them as such. Try to 'read' the form within the image, and construct your drawing using your existing knowledge or other references.

Altering the composition

If a photograph contains something that you feel is upsetting the composition, remove it and, if necessary, put something else in its place.

Using videos

Videotapes can provide an exciting source of reference, especially if you have a recorder capable of playing slow motion or stopping to show a single frame at a time. Such a tool would be indispensable if you wanted to study movement in detail.

I included the pair of horses in my drawing, but added a foal in the foreground for extra interest. I was still unhappy about the composition, however: the backs of the horses cut too strongly across the photograph. To remedy this, I inserted a tree into the background. Including these two extra elements, I felt, was enough to improve both the composition and make the picture more interesting.

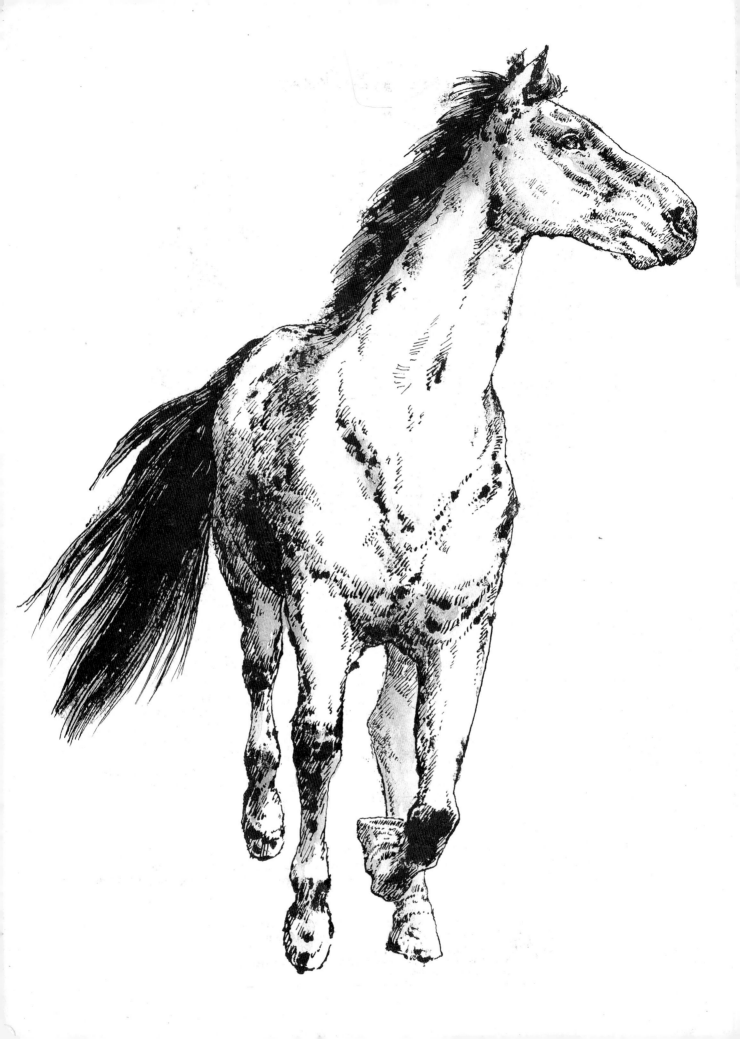